SUCCESS IN ART

MASTERING PERSPECTIVE

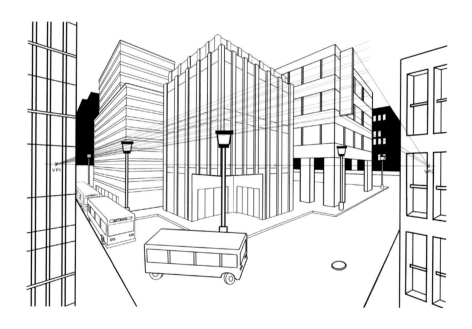

ANDY FISH

Brimming with creative inspiration, how-to projects, and useful information to enrich your everyday life, Quarto Knows is a favorite destination for those pursuing their interests and passions. Visit our site and dig deeper with our books into your area of interest: Quarto Creates, Quarto Cooks, Quarto Homes, Quarto Lives, Quarto Drives, Quarto Explores, Quarto Gifts, or Quarto Kids.

First published in 2020 by Walter Foster Publishing, an imprint of The Quarto Group. 26391 Crown Valley Parkway, Suite 220, Mission Viejo, CA 92691, USA.
T (949) 380-7510 F (949) 380-7575 **www.QuartoKnows.com**

Walter Foster Publishing titles are also available at discount for retail, wholesale, promotional, and bulk purchase. For details, contact the Special Sales Manager by email at specialsales@quarto.com or by mail at The Quarto Group, Attn: Special Sales Manager, 100 Cummings Center, Suite 265D, Beverly, MA 01915, USA.

ISBN: 978-1-63322-858-0

Digital edition published in 2020
eISBN: 978-1-63322-859-7

Printed in China

10 9 8 7 6 5 4 3 2 1

Table of Contents

Introduction

The world around us exists in three dimensions, and it took several hundred years for artists to figure out how to depict this quality within the two-dimensional world of illustration.

When we look at early artwork from the pre-Renaissance period, we often see the world in rich detail and color but lacking depth. These works, while certainly masterpieces, have little representation of the three-dimensional world. Simply put, these early artists depicted people stiffly in place with little or no relation to the world around them.

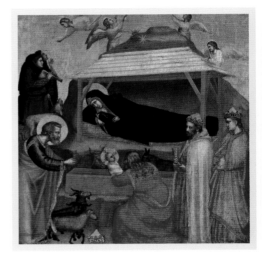

Giotto di Bondone, *The Adoration of the Magi*, c.1320

One hundred years before Galileo experimented with gravity, and long before Sir Isaac Newton gave that element of nature a name, Italian artist Filippo Brunelleschi (1377-1446) painted what is considered to be the first use of linear perspective, depicting the Florence Baptistery from the front gate of the unfinished cathedral using "vanishing points" to which all lines converged at eye level on the horizon.

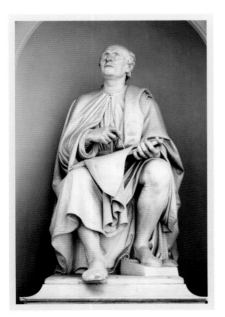

Soon after, the concept gained popularity and many Italian artists began to use linear perspective in their paintings. Masaccio (1401-1428), often considered the first great painter of the Renaissance period, was among the first to demonstrate a command and understanding of the new rules of perspective. His buildings and landscapes receded into the distance, giving his figures a sense of place and offering an image that in essence, "looked right."

Luigi Pampaloni, *Statue of Filippo Brunelleschi*, c.1838

Artists today still struggle with the strict rules of perspective, and many simply abandon hope to ever fully understand those rules. Perspective can be intimidating because it involves not just imagination, but also an ability to follow strict rules, proportions, and precise lines. No creative person likes to be stifled by rules, but maintaining a firm grasp on the art of perspective requires you to completely understand those rules before you attempt to bend or break them.

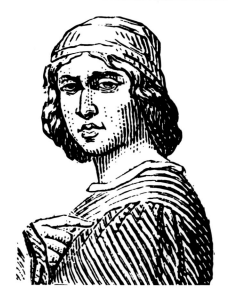

Masaccio (1401-1428)

We all want to get to the good stuff, and we all think we know more than we really do. Resist the temptation to skip ahead; instead, follow each lesson as written. Do them once; do them again. Do them until you are certain that you understand all the principles and rules of each chapter before you move on.

Don't skip the basics because you think you know them. Let's review and make sure you aren't missing something essential in the "easy" lessons, because that will trip you up as you get further into the studies.

Trust me on this one—there has never been a better case of learning how to crawl before you can walk!

One of the key elements to the success of drawing is to ensure that your vanishing points are concise. Because they are called vanishing "points," many artists draw them as a small dot (or point). The problem is that when you draw your vanishing point as a dot and then continually work with that same dot, tapping your pencil on that same starting point again and again, the dot will inadvertently grow as you work—and that is very bad. If your vanishing point varies by even a millimeter, it can create an abstract line as you extend your perspective lines.

This book will explore a great deal, from simple to complex perspective, in simple step-by-step lessons. We'll build up difficulty from one lesson to the next; follow me, and we'll try our best to have some fun along the way.

Getting Started: The Essentials

You need both the right environment and tools to create accurate perspective in your drawings. It's a precise art form, and spending a few minutes up front to prepare your materials and space will eliminate a lot of frustration.

Studio Space

A good studio space is a great investment. A complex illustration in perspective can take hours or even days to complete, so you want to have a comfortable place where you can leave the work for periods of time without having to pick everything up and put it away. It doesn't have to be an elaborate studio space (although that's a big plus); it can be as simple as a portable drawing board in a corner of a seldom-used room.

Drawing Board

It makes sense that you would need a comfortable chair and a solid drawing table or portable drawing board. The tabletop should be angled so that your work doesn't distort. Portable drawing boards allow you to work on a regular desktop. Your drawing area should be at least three times the size of whatever paper you're working on; often, vanishing points must be set well outside the art board.

Charles Dickens once wrote, "When happiness shows up, give it a comfortable chair." You'll appreciate this sentiment when you're on hour 36 of your masterpiece. Buy the best one you can afford, and it will pay for itself in comfort.

It can be helpful to have a portable drawing board, as well as a computer or tablet nearby, so that you can switch between traditional and digital drawing, if necessary.

Erasers

I prefer the white or colored polymer erasers over the gummy erasers or pink erasers. These vinyl erasers are extremely effective, and they create far less mess.

Pencils

A sharp pencil. That might sound ridiculous, but a fine-point sharp pencil is very important because perspective requires precise lines. Working with a dull pencil will only lead to frustration. Traditional pencils are fine, but expect to do a lot of sharpening. Mechanical pencils are a great option, and there are several brands that automatically rotate the lead while you work to avoid a dull edge.

Use a lead of at least HB weight, or even better, a harder lead like a 2H or a 3H. Harder pencil lead will be less likely to smudge, and for perspective lines, you'll want to apply a very light pressure to your line. Keep in mind that harder leads are also more difficult to erase.

A non-photo (or non-repro) blue pencil or pencil lead is a popular choice. This pencil creates a light blue line that is easier to eliminate when printing. It's also nice to build your perspective lines in non-photo blue to make your "regular" pencil lines more visible.

Lighting

You're going to need a lot of light. If you're right-handed, I'd suggest a regular desk lamp on your left (reverse these suggestions if you're left-handed) and a draftsman adjustable light on your right. You need to be able to see what you're working on, and bad lighting can create shadows that will get in your way.

Paper

Some artists prefer drafting paper, but I like 3-ply Bristol board. It holds up well and takes pencil lines very well. Bristol comes in two finishes, vellum and plate; you'll want to avoid vellum when working with perspective, as the rough surface will keep your pencil lines from being precise. Choose plate, the smoother of the two.

Tape

You'll need to secure the drawing to your board, and you want a tape that will hold things in place but won't cause damage when you try to take it off. For this reason, I recommend a popular blue painter's tape sold in any hardware store.

Rulers, T-squares & Triangles

All three of these tools are essential, and I recommend metal or plastic when it comes to rulers and T-squares. Wooden tools warp and chip, and they don't have the same hard edge that metal does. In between projects, clean them off with a rag and some gentle household or window cleaner; with use, they pick up a lot of lead dust, and keeping them clean will help keep your work clean.

The last item is Music...

I like to make a good digital playlist that runs about 4½ hours before I start a project. That way I can get lost in the world of creating and not waste time trying to find something to play in the background.

All right, we have all our tools and work space ready—it's time to get to work.

Understanding Basic One-point Perspective

One-point perspective is the most basic form of perspective illustration; but it's also the foundation for all the other forms of perspective, making it fundamental for understanding the more advanced levels of perspective.

The Importance of Working Precisely

The precision of perspective scares a lot of artists because you can't fake it—you must follow the measurements precisely if you want your drawings to work.

It's vital to the success of your project to keep your vanishing points concise. Many artists place their vanishing points as a dot (or point). As you tap your pencil repeatedly over this small starting point, it will inadvertently grow—which will prove disastrous. If your vanishing point varies by even a millimeter, it can create a false result as you extend your lines.

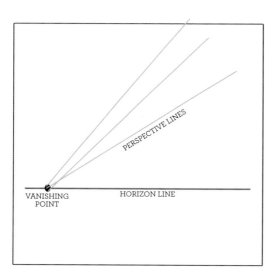
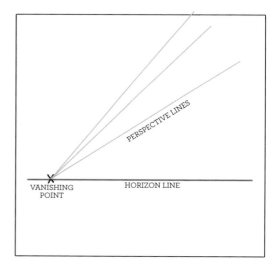

Example 1 Using a dot as the vanishing point seriously affects the perspective lines as they extend into the distance. A dot lacks the focal point needed for precise, effective perspective.

Example 2 Using an X as the vanishing point ensures a precise starting point for the perspective lines, creating an accurate correlation as they extend into the distance. This minor step will make a major difference in your perspective illustration.

The Elements of Perspective

Whether we're working in one-point perspective or infinite-point perspective, each and every drawing utilizes the same basic elements. Let's take a look at two examples, using one-point perspective.

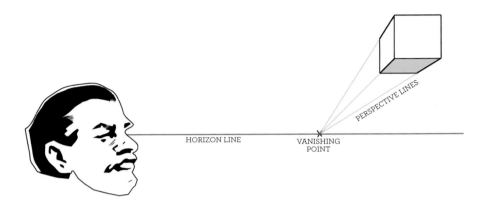

Horizon Line This is essentially your viewer's eyeline or their point of view (POV). If you were standing in an open field, the horizon line would be level with your POV. If you place a box above the horizon line, you would be able to see the underside of the box, as seen here (the orange side).

Vanishing Point The point at which all your perspective lines intersect. Let's go back to that imaginary open field; now place a set of railroad tracks directly in front of you, traveling away into the distance. The point where they seem to converge is the vanishing point.

Perspective Lines These are the lines that go from the vanishing point to the object that you are attempting to render in 3-D (in this case, the box).

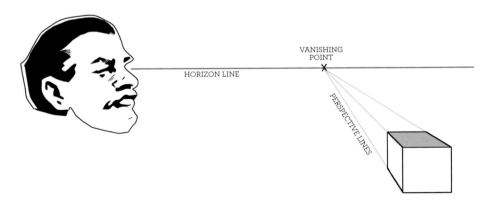

Try placing the box below the horizon line. The elements remain the same, but the outcome is different because you can now see the top of the box (the green side).

Both of these examples are considered one-point perspective because there is only one vanishing point. Understanding the elements of perspective allows us to use them correctly as we begin to render more complex illustrations in perspective.

The Basics: Step by Step

Let's learn how to draw a simple box using one-point perspective.

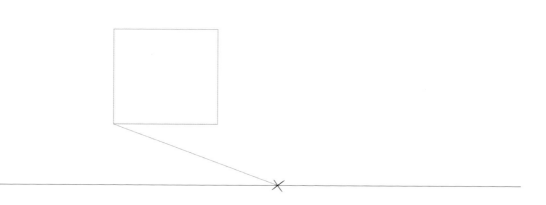

HORIZON LINE

Step 1 Tape the paper to your drawing board at the four corners to keep it secure. Draw a horizon line across the page, and then place a vanishing point (use an X) about halfway across.

Step 2 Draw a square above the horizon line. Keep the lines light using gentle pressure or a non-photo blue pencil. The square should be even, so take your time.

Step 3 Starting at the vanishing point, draw a line from the direct center of the X up to the bottom-left corner of the square. Make sure you are precise, starting at the center of the vanishing point and hitting that bottom corner. Accuracy counts.

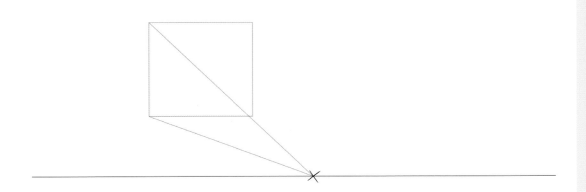

Step 4 Go back to the vanishing point to draw a line from the center of the X up to the top-left corner of the square. Notice that the line goes through the square. Don't let this confuse you later.

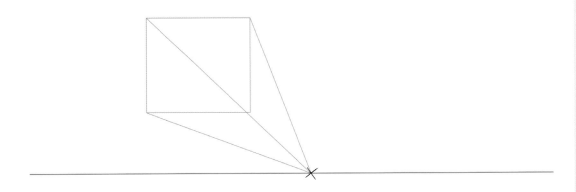

Step 5 Starting at the vanishing point, draw a third line up to the top-right corner of the square.

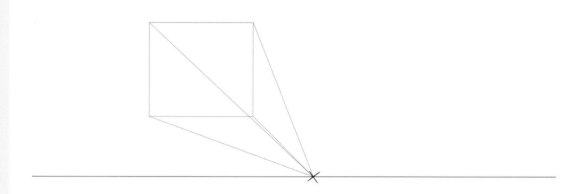

Step 6 You guessed it! Draw a fourth line from the vanishing point's direct center up to the bottom-right corner of the square.

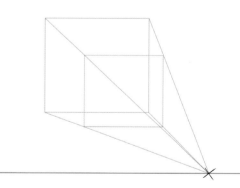

Step 7 Now draw another square inside the perspective lines you've just drawn. You get to decide where the square will sit based on how deep you want the cube to be.

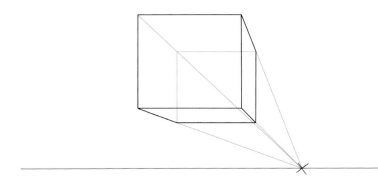

Step 8 Using a darker pencil, trace over the final lines for the cube. Because we're trying to demonstrate a 3-D cube, carefully choose the lines that should be visible and ignore the ones that go through and behind the cube.

Step 9 Erase your perspective lines, and clean up your final cube lines. You now have a nicely rendered three-dimensional block!

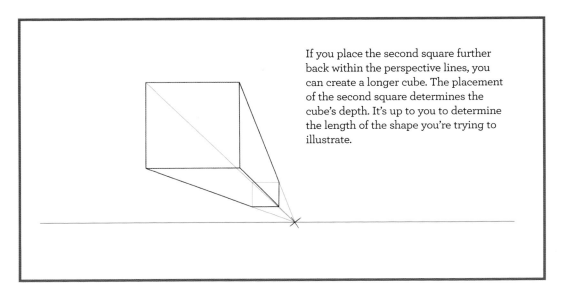

If you place the second square further back within the perspective lines, you can create a longer cube. The placement of the second square determines the cube's depth. It's up to you to determine the length of the shape you're trying to illustrate.

Building Blocks: A Variety of Shapes

Now let's try the same thing, but with a few different shapes set at different points on the horizon line, and see how they work in perspective.

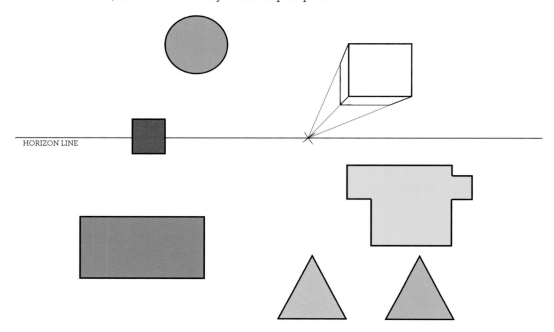

HORIZON LINE

Step 1 Go back to your original square and add a few more square-based shapes, as well as a couple of triangles and a circle.

To recap, with one-point perspective, all of the shapes facing us are flat, as if they were hanging on a wall. Their placement above or below the horizon line determines whether we will be able to see the top, bottom, or side of a particular shape.

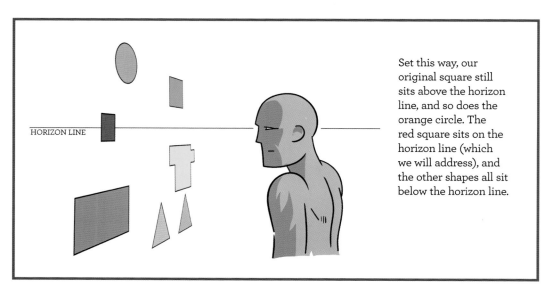

HORIZON LINE

Set this way, our original square still sits above the horizon line, and so does the orange circle. The red square sits on the horizon line (which we will address), and the other shapes all sit below the horizon line.

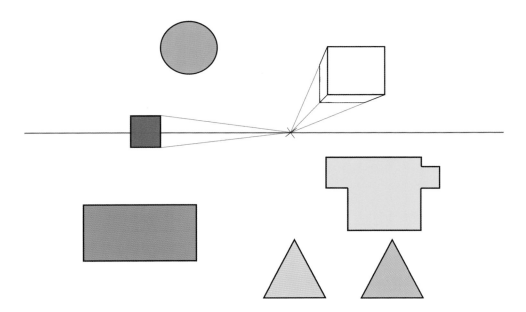

Step 2 Because the red square sits on the horizon line, we are only able to see the lines from the top-right and bottom-right corners (we cannot see the top or bottom sides). Draw your perspective lines from the vanishing point to its top and bottom corners.

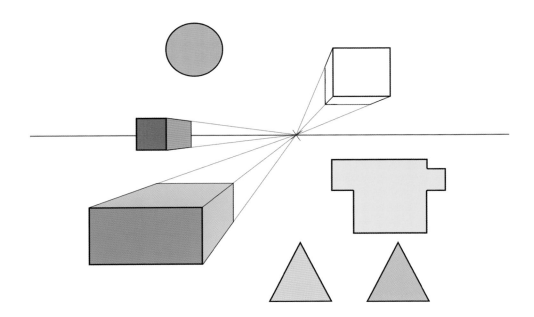

Step 3 Close off the lines on the red square, and then follow the basic steps on pages 12-15 for the blue rectangle that sits below the horizon line. Once you've drawn the perspective lines, close off the rectangle. Because it sits below the horizon line, we can see the top and side of the shape (opposite what we see for the original white square above the horizon line).

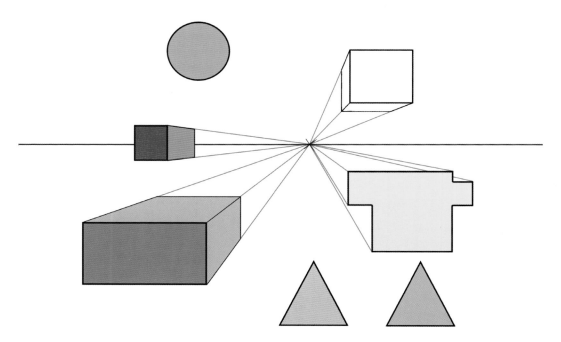

Step 4 Move on to the yellow shape. Add perspective lines from each corner back to the vanishing point; the lines from the middle-right bottom corners and the bottom-right corner are not visible behind the shape, so don't draw lines from those.

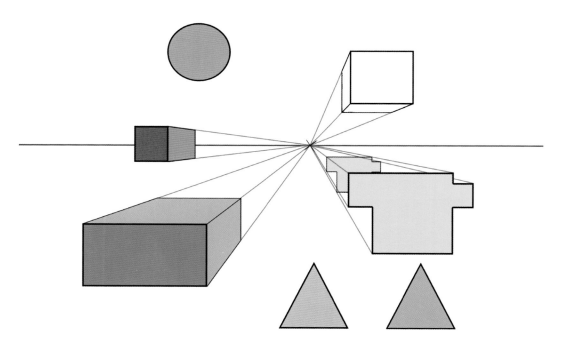

Step 5 Draw the back of the yellow shape, using the vanishing lines to match up all of the visible corners. Take a minute to really see and understand where each of the lines start and end.

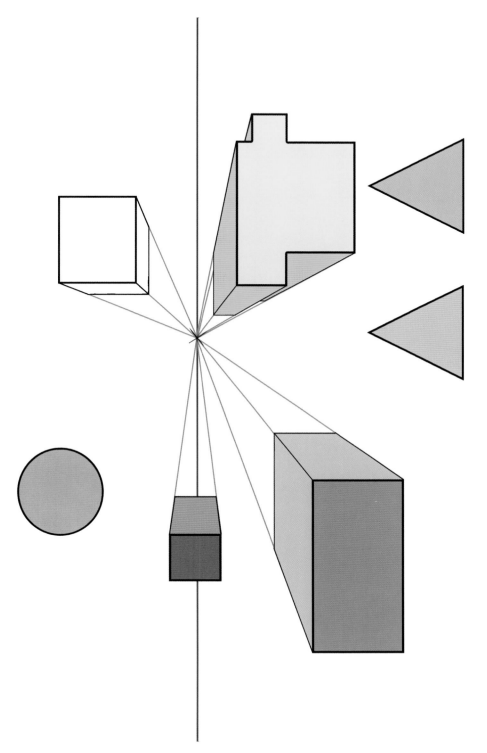

Step 6 Now close off the yellow shape by following the perspective lines. Remember, you as the artist can choose the depth of each shape.

19

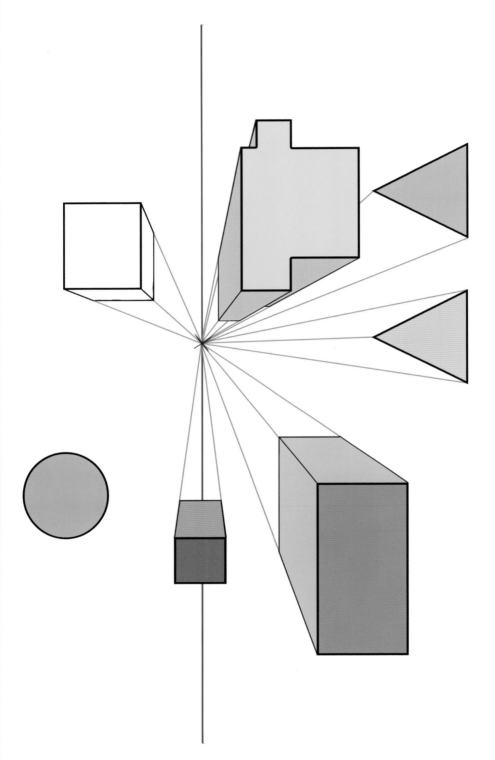

Step 7 The purple triangle sits almost directly underneath the vanishing point, so we can see all three corners; but the green triangle is farther to the right, obscuring the third corner line, so we can only see two lines for that one.

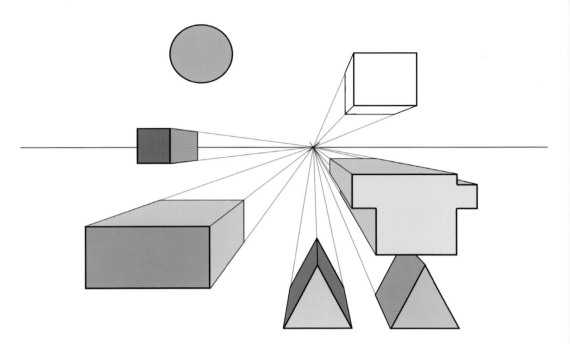

Step 8 Close off both triangles, and trace over the perspective lines. The back of the green triangle sits under the yellow shape, so we cannot see part of it due to the angle.

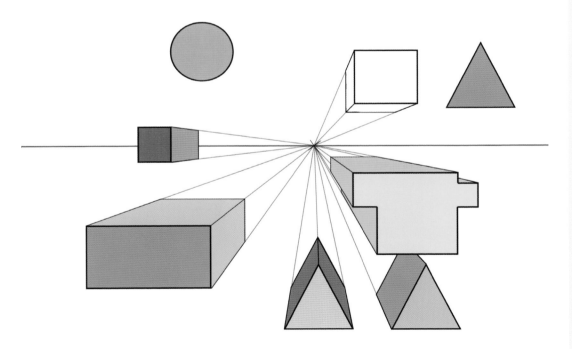

Step 9 Let's float another blue triangle up above the horizon line to see how the angle affects the perspective.

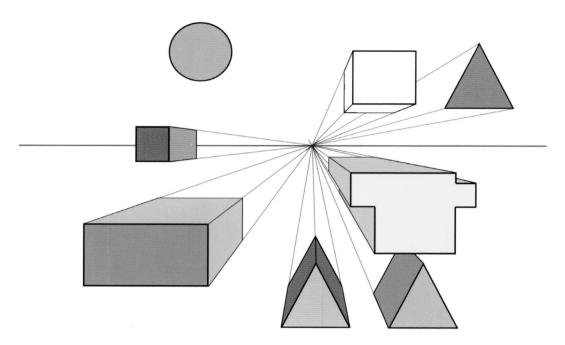

Step 10 Draw the perspective lines from the vanishing point to the three visible sides of the blue triangle. Because it floats above the horizon line, we can see the bottom and the left side.

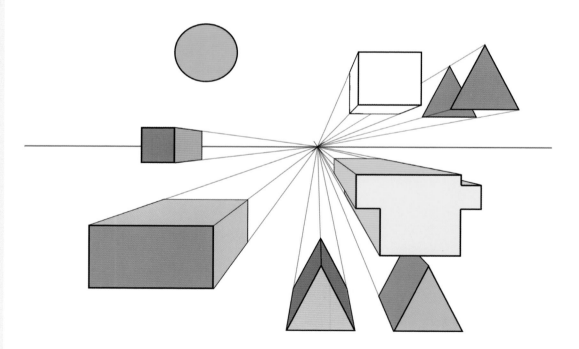

Step 11 Draw the back of the triangle by following the perspective lines.

Step 12 Now close off the triangle edges following the perspective lines.

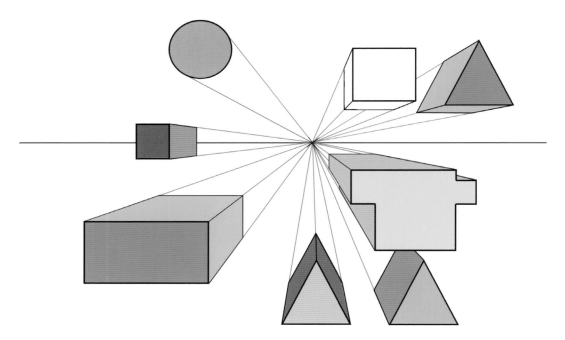

Step 13 So, how about that circle? How do we handle a shape in perspective if it has no corners? Simple. Rather than drawing lines from the vanishing point to the corners, simply draw them to the furthest edge on each side of the circle.

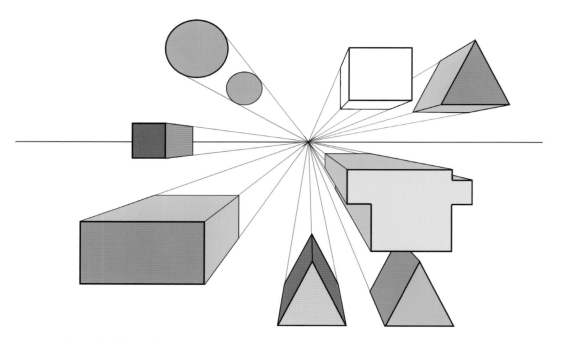

Step 14 The back of the circle, which now turns it into a cylinder, should stay within the perspective lines. Its placement determines the cylinder's length.

Step 15 Close off the cylinder, and then darken the exterior lines to finish.

Taking One-point Perspective to the Street

Now that you understand the basics of one-point perspective using shapes, let's practice with a simple one-point perspective drawing of some buildings.

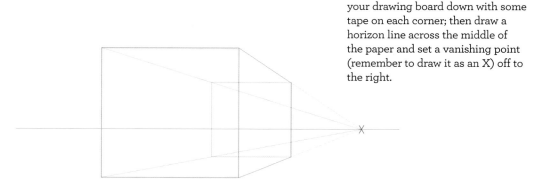

Step 1 Begin as always by securing your drawing board down with some tape on each corner; then draw a horizon line across the middle of the paper and set a vanishing point (remember to draw it as an X) off to the right.

Step 2 Draw a simple block on the horizon line using the vanishing point (see pages 12-15). Remember, all of the front lines (the side facing us) should be either vertically or horizontally straight. The edges of the block (along the right side) follow back to the vanishing point. Make sure you draw all of the perspective lines as if the block were hollow, so we can see the hidden walls on the far side.

Step 3 Place another square up against the left side of the block, so that the right corners of this new square connect to the hidden perspective lines. Because of the angle, we cannot see any of the lines that go from this square back to the vanishing points.

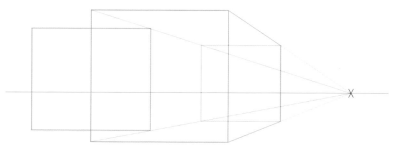

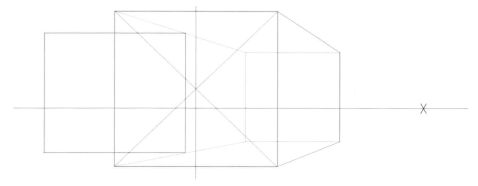

Step 4 Now let's start building up the block. First, find the center point of the first block. Draw an X from corner to corner in the front square, and then draw a vertical line up through the X, which divides the front of our block into two even pieces.

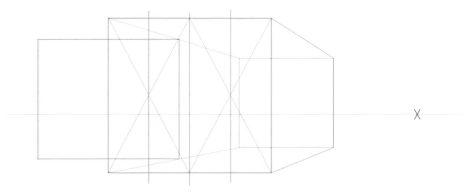

Step 5 Repeat this same technique in each of the two pieces you've created. Now you've divided the block face into four pieces.

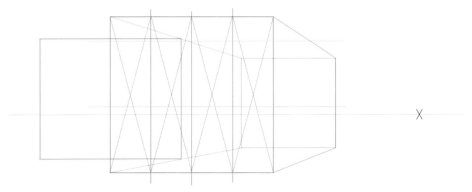

Step 6 Repeat this technique again in each of these four pieces. Dividing the block face into this many segments will make it easier to drop in windows.

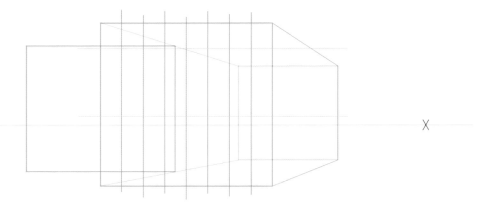

Step 7 Now draw the two lines that will represent the top and bottom of the windows. No measurement required; just eyeball it to about the size you think the windows should be.

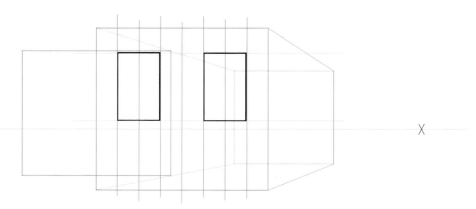

Step 8 Following the guidelines, draw in the windows on the front of the block with simple vertical and horizontal lines, no perspective required.

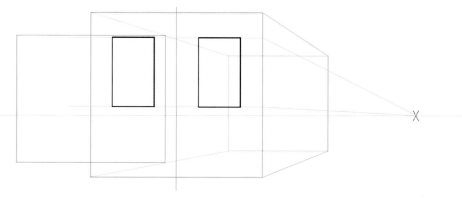

Step 9 Next, we are going to add windows to the right wall of the block, which will involve perspective. From the top and bottom lines of the front windows, draw a line from the right edge of the block back to the vanishing point; this sets the height of the side windows.

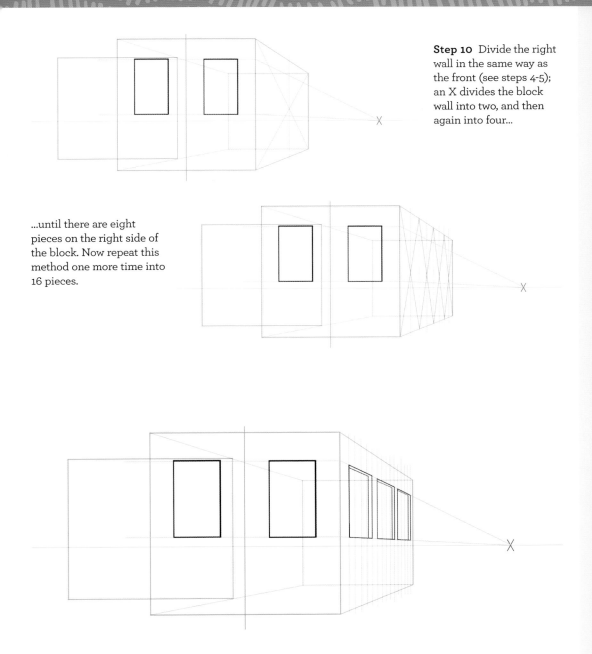

Step 10 Divide the right wall in the same way as the front (see steps 4-5); an X divides the block wall into two, and then again into four...

...until there are eight pieces on the right side of the block. Now repeat this method one more time into 16 pieces.

Step 11 Use these 16 spaces to draw in the side windows. The perspective lines will determine the height of the windows. Because of the angle, we can see the interior windowpanes; the inside lines along the top should follow the perspective line, as they are above the horizon line. The inside lines along the side are simply vertical.

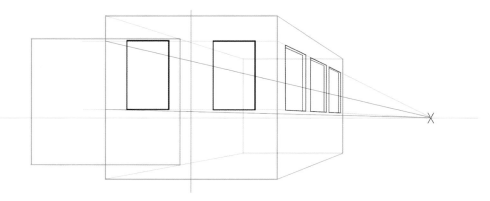

Step 12 In order to place the windows on the attached block, draw perspective lines from the far left edge of the first block back to the vanishing point (above in red).

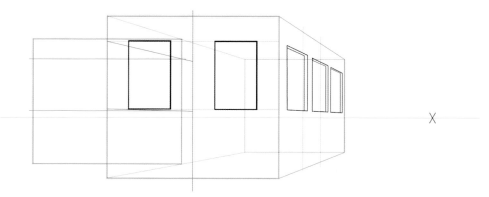

Step 13 Add two horizontal lines across the square from the points where these new perspective lines intersect with the edge of the attached block face.

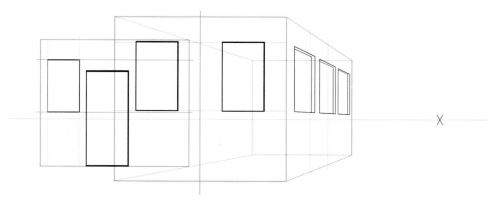

Step 14 The height of the window is determined by these horizontal lines; we're not going to bother to break down the measurements, but we know approximately how wide this window should be by looking at our other windows (so that they look like they match). You can also rough in a door.

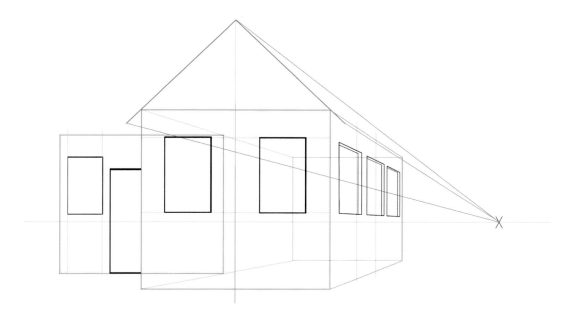

Step 15 To add the roof, simply extend the centerline of the front block up, and then draw two roof lines down from the point just past each corner of the block (these lines do not go to the vanishing point). The top of the roof does go to the vanishing point, and so do the edges.

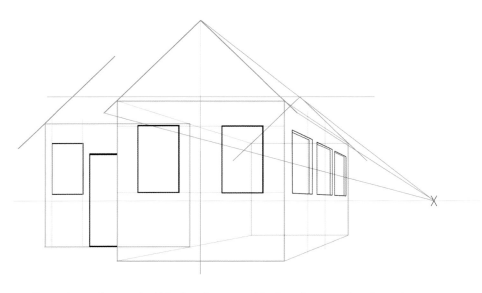

Step 16 The roof over the attached block is determined by first drawing a line from the top-corner point of the back end of the roof over and above the block. The angle of the roof edge should be the same as the roof angles of the main building.

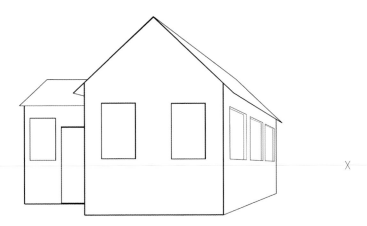

Step 17 Clean up your lines so that you can move on to the sidewalk.

Step 18 The front edges of the sidewalk are simple horizontal lines. The lines from the door and moving down the street all go to the vanishing point. To give the sidewalk some depth, add double lines for the curb. Add a street behind the house to make it appear to sit on a block. Use the same rules but eyeball the width of the street.

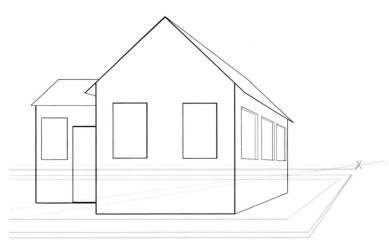

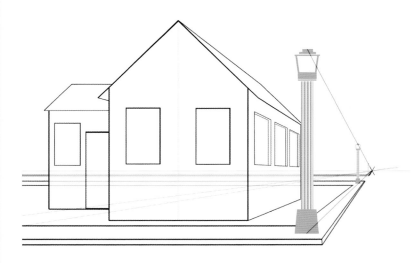

Step 19 Perspective can also help with the streetlights. Simply put, as long as the streetlights are on the same line, or in this case the same sidewalk, then we can add perspective lines from the top of the lamp and the bottom of the lamp back to the vanishing point. Any additional lamps should fall between these perspective lines.

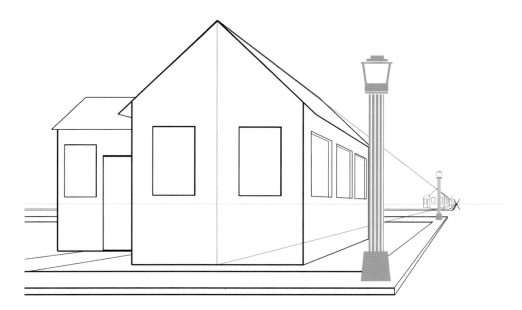

Step 20 The same rule used for the streetlights can be applied to anything else. For example, if you want to draw another house on the next block, you can simply draw lines from the centerline of the first house back to the vanishing point, and then draw the second house within those lines (this would make the houses the same size).

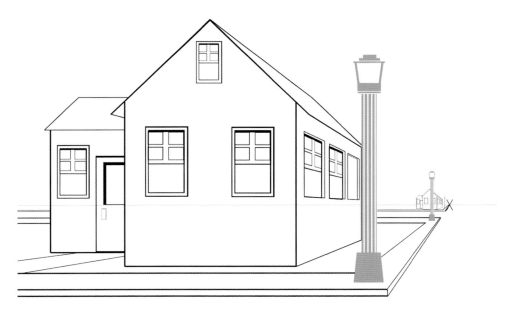

Step 21 For any additional details or elements, be sure to follow the rules outlined in this lesson. So there you go—simple one-point perspective in action.

One-point to Two-point Perspective

Okay, we've used some simple one-point perspective to draw blocks and shapes in perspective. One-point is a perfectly acceptable way to represent 3-D images in a 2-D illustration, but what if you're not standing directly in front of one of the surfaces?

Welcome to Two-point Perspective!

First, make sure you understand the basics of one-point perspective, which we covered in the previous two chapters (pages 10-33). Give them a second look, if needed.

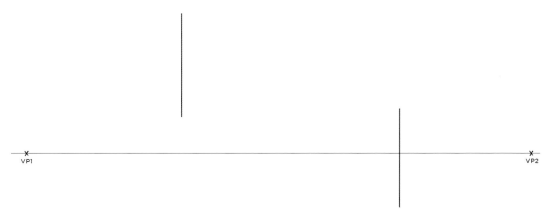

Step 1 Once again, start with a horizon line; only this time, instead of one vanishing point, we're going to place two vanishing points. Both points should be on the horizon line. The further out you place them, the less distortion you'll have with your image. Make sure to follow the rules and make the vanishing points Xs, not dots! In two-point perspective, the vertical lines are all straight up and down, while all of the horizontal lines will extend to either Vanishing Point 1 (VP1) or Vanishing Point 2 (VP2), depending on which side of the block they are on.

Step 2 Place two block-edge lines in your drawing; set them apart from each other, but not too close to either vanishing point. Otherwise you'll create extreme distortion (which we'll get to a little later). One edge line should sit up above the horizon line, while the other should intersect the horizon line so that we can see how this affects the visibility of the block.

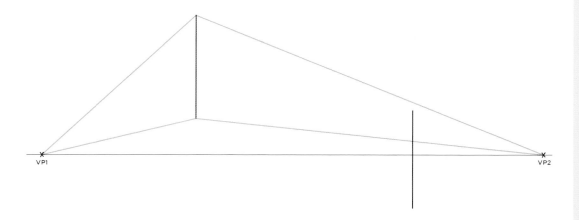

Step 3 Starting with the first block edge, draw perspective lines from the top and bottom back to VP1 to create the left side of the block. Draw two more perspective lines to VP2 to create the right side of the block. Don't get confused as these lines cross over your second block; just ignore that edge line for now.

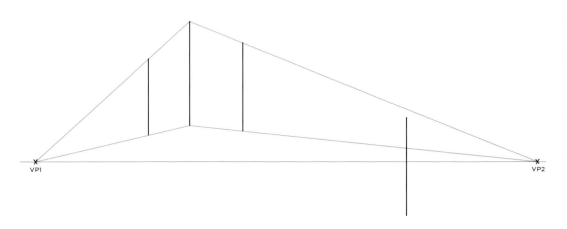

Step 4 Establish the length of the first block by placing lines somewhere between the perspective lines on each side. They can go anywhere as long as they fall between the perspective lines.

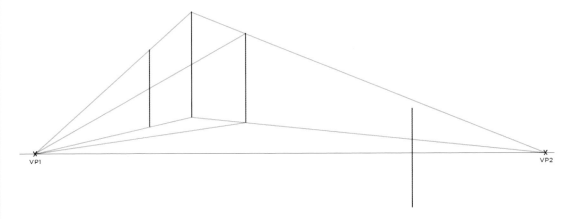

Step 5 Okay, this is where it gets a little confusing. Draw two perspective lines from the outer-right edge line of our block back to VP1. These lines will go through the box, making it look like a transparent three-dimensional cube. These lines will help establish the base of the block, which we can see because the block is set above the horizon line.

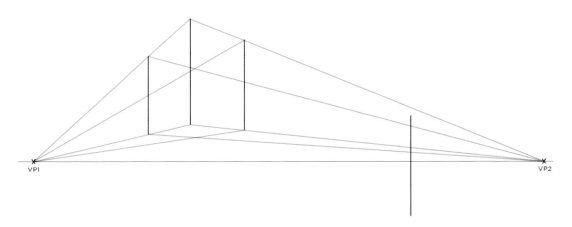

Step 6 Do the same thing from the outer-left edge line back to VP2.

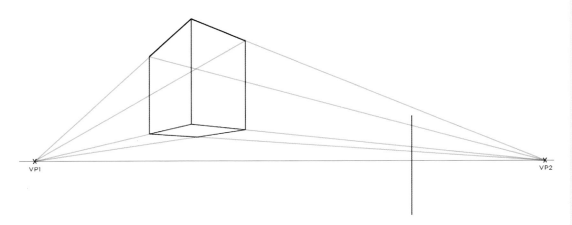

Step 7 Close off the top and bottom lines of the block in black to create a finished cube.

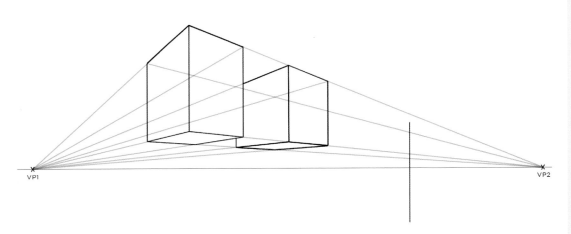

Step 8 You can add multiple blocks that exist on the same plane by following the same perspective lines.

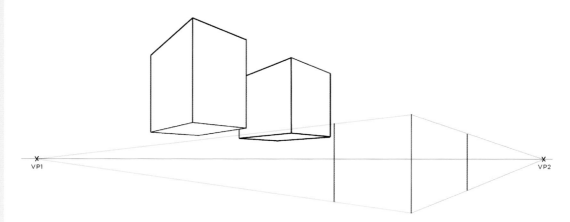

Step 9 Now let's work on the other block edge, which sits on the horizon line. Make similar perspective lines from the top and bottom back to VP1 for the left side and VP2 for the right side.

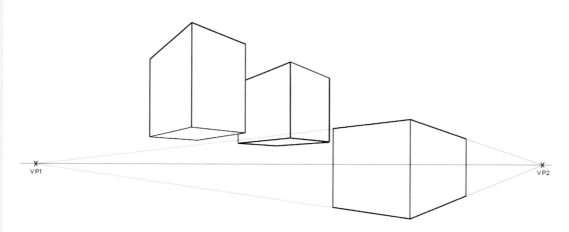

Step 10 Set the length of the box within the perspective lines. Lastly, simply close off the top and bottom lines of the block. You don't need to draw perspective lines from the hidden side because it's sitting on the horizon line, which means we can't see the top or the bottom of the block from this angle.

Block 1

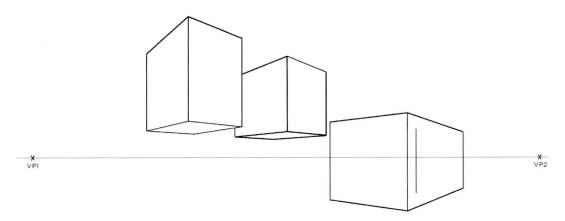

Step 1 But how do we take pieces out of the blocks (like a window)? It's pretty simple. Start by adding an edge line inside the face of the block.

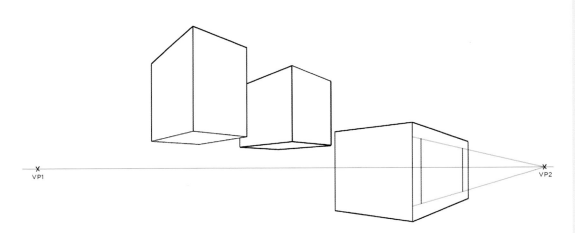

Step 2 Now draw perspective lines from the top and bottom edge of the window line to VP2 (because we're on the right side of the block). Extend the lines to the front edge of the block face (this will come in handy in step 5).

Step 3 Draw in the back end of the window, placing it inside the perspective lines.

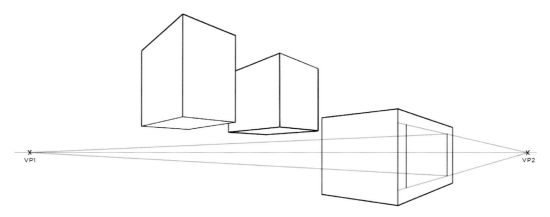

Step 4 Draw perspective lines from the back end of the window to VP1. Don't finish off these lines yet—let's put a window on the left side first...

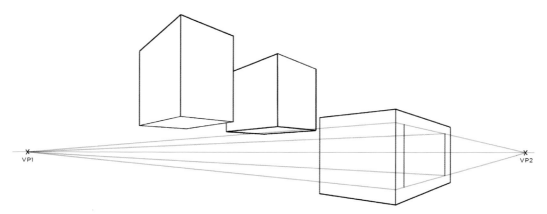

Step 5 Draw perspective lines from the front edge line (where the lines met the block face in step 2) back to VP1. This will allow you to add a matching window to the left side of the block.

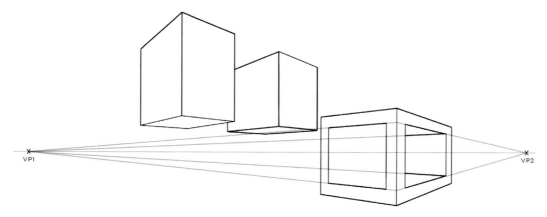

Step 6 Draw in the vertical edges of the left-side window, staying within the perspective lines. Close off the top and bottom lines for both windows (as well as the lines of the window on the back side of the block).

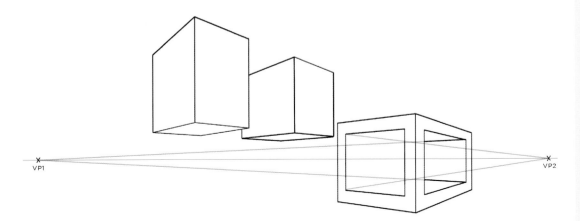

Step 7 Erase some perspective lines to "see" things a bit clearer. For the inside of the left-side window, draw new perspective lines from the inside left-hand corners to VP2.

Note where these new perspective lines cross those for the right-side window. If they had intersected at a point inside either window, you'd have to draw the block's back corner edge.

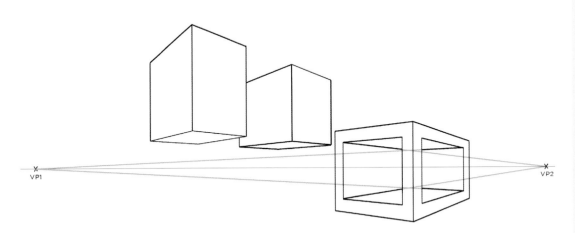

Step 8 Draw in the interior window lines.

Block 2

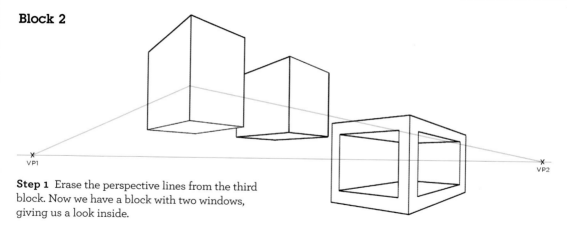

Step 1 Erase the perspective lines from the third block. Now we have a block with two windows, giving us a look inside.

Next let's cut a chunk out of one of the other blocks. Using perspective lines, choose a point on the first block and draw back to VP1 and VP2.

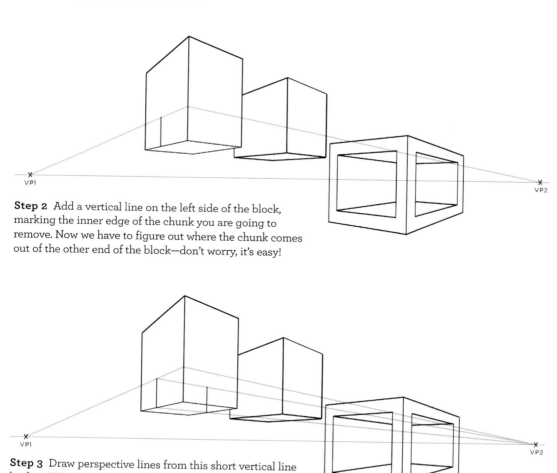

Step 2 Add a vertical line on the left side of the block, marking the inner edge of the chunk you are going to remove. Now we have to figure out where the chunk comes out of the other end of the block—don't worry, it's easy!

Step 3 Draw perspective lines from this short vertical line back to VP2. Draw a second edge line where the perspective lines intersect the outer edge of the block.

42

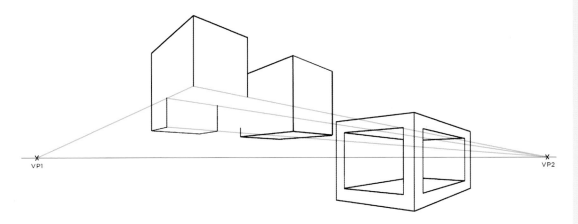

Step 4 Erase the outside corner lines of the block to "cut out" the chunk.

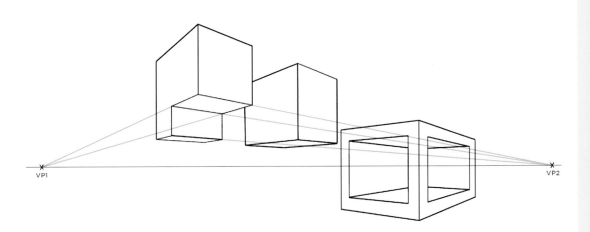

Step 5 Draw a perspective line from the new bottom-right corner back to VP1. Close off these new perspective lines. Note that we can now see more of the second block that is floating behind the first block. Extend the back left-edge line now that it is visible.

Block 3

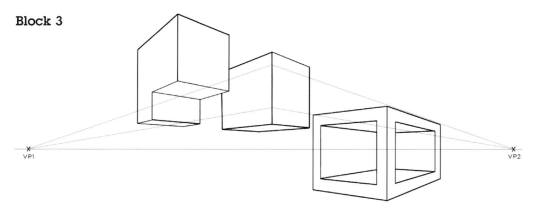

Step 1 Let's cut a chunk out of the last block to be sure we understand vanishing points and perspective lines. Choose two points on the front corner of the block and draw perspective lines back to VP1 and VP2.

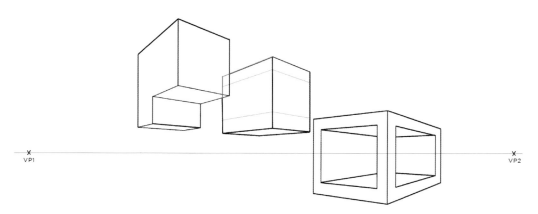

Step 2 Add in the top-left corner of the block (see new red lines), as you need to know where these lines are in order to make the cut accurately.

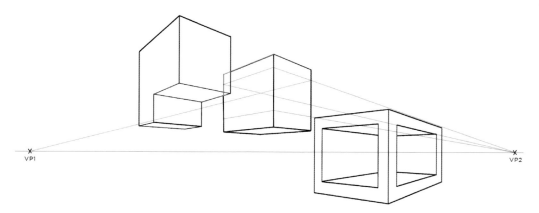

Step 3 Add perspective lines back to VP1 and VP2 in order to "see" the underside of the block's top.

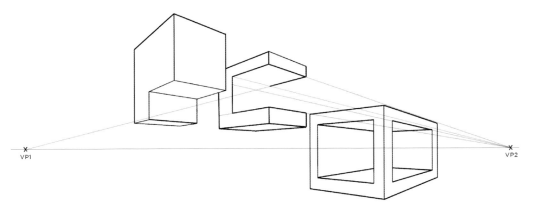

Step 4 Next, choose the new back line of the block, which should be parallel to the back edge and based on how thick you want the back wall to be. From the top of this line, draw a perspective line back to VP2 to determine where to place the rear edge line of the block's top. Following the perspective lines, add in permanent lines around the bottom edge of the newly cut block.

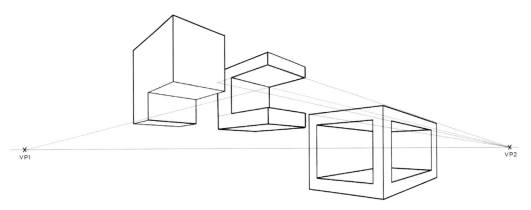

Step 5 Again, following the perspective lines, draw in the edge line underneath the block's top to where it intersects with the underside edge in the back corner. From this back corner, draw a vertical line down to the base of the block.

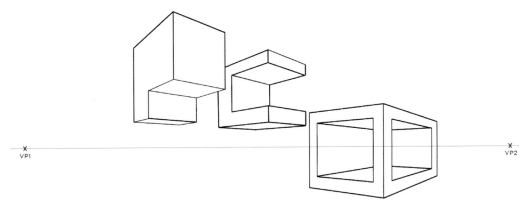

Step 6 Erase the perspective lines and see how perspective affects the blocks. When the block sits above the horizon line, we can see the lower portions of the block. When the block sits on the horizon line, we can see neither the top nor the bottom planes of the block.

Two-point Perspective: Put It to Work

A quick word about technique: The ability to see your lines, but also the ability to see through lines as they build up, is crucial to ensuring your illustration looks correct. Here we will draw three buildings in two-point perspective.

When working in perspective, you'll get better results if you can work very cleanly:
• Keep erasing to a minimum.
• Keep your line work reasonably light; work with a light colored pencil or ink color (if you're working digitally) for your perspective lines.

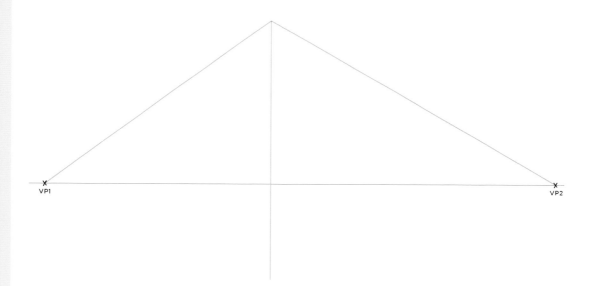

Step 1 Set Vanishing Point 1 (VP1) to the left and Vanishing Point 2 (VP2) to the right on the horizon line. Remember to use precise Xs, rather than dots. Place the first building in the center of the illustration about midway through the horizon line. Extend the vertical line to the height you'd like the building to be. At the top of this line, draw the right slope of the roofline to VP2 and the left to VP1.

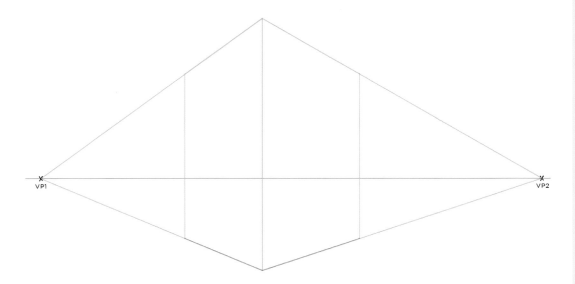

Step 2 Now do the same thing for the bottom of the building. Add vertical ends on either side of the first vertical line. The width of the block is up to you.

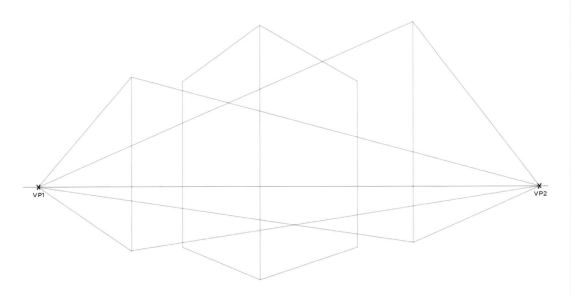

Step 3 Erase the leftover perspective lines for this first block to make things easier to "see." Now add vertical lines for a second and a third block and add perspective lines going to VP1 and VP2. Vary the lengths of these vertical lines to create buildings of different heights.

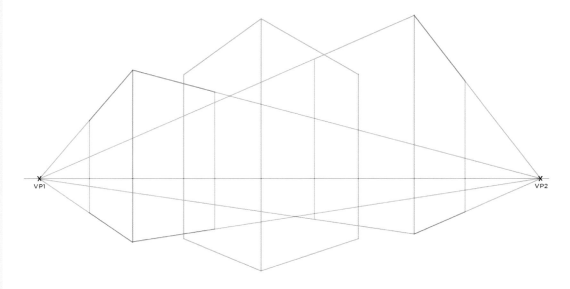

Step 4 Close off these new blocks with their own vertical ends.

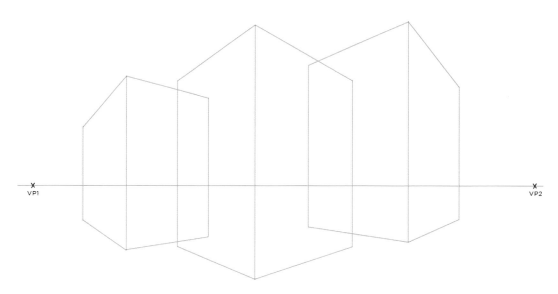

Step 5 Erase the perspective lines and you've got three buildings. Notice that the blocks on the right and left seem to be floating.

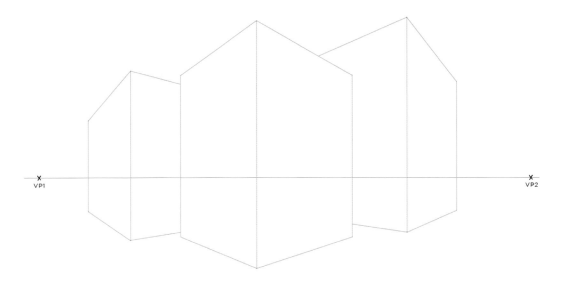

Step 6 Eliminate this optical illusion by erasing the lines that would be hidden when viewed from the front. Now their placement in the foreground should be much clearer.

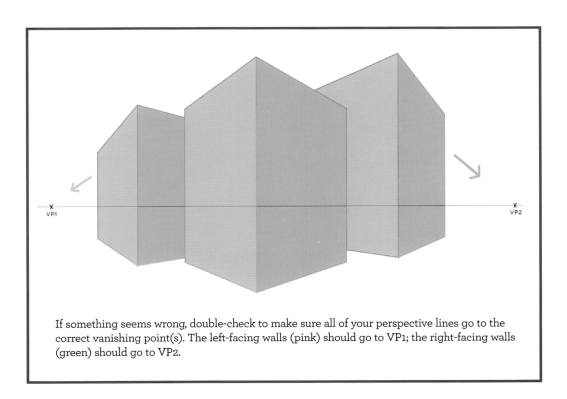

If something seems wrong, double-check to make sure all of your perspective lines go to the correct vanishing point(s). The left-facing walls (pink) should go to VP1; the right-facing walls (green) should go to VP2.

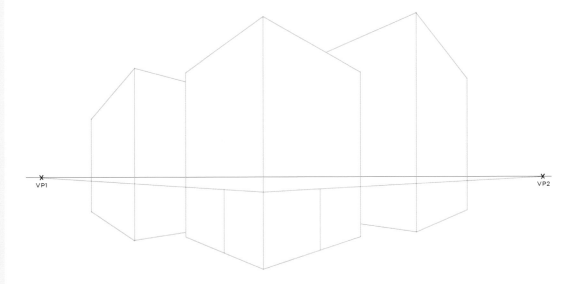

Step 7 Often, I like to "build" on to the existing lines. This allows you to easily add to your buildings or remove pieces to create more interesting architecture. Start by cutting out the bottom-front corner of the first building by drawing two perspective lines to VP1 and VP2 with two vertical lines that extend to the base of the block on each side.

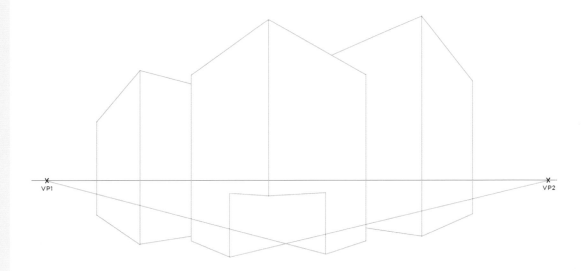

Step 8 Erase the front and bottom lines to create the cutout. Create new interior lines by drawing perspective lines from the bottom corners to their opposite vanishing points.

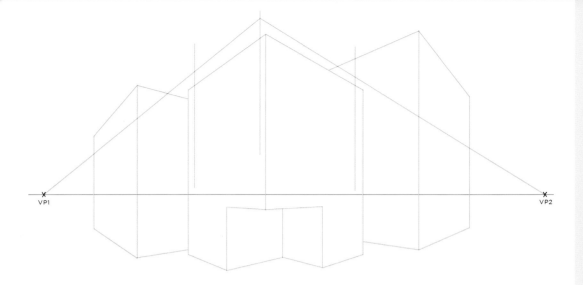

Step 9 Place the interior vertical edge where these two lines intersect. Next add a "penthouse" to the roof, again using three vertical lines and perspective lines to VP1 and VP2.

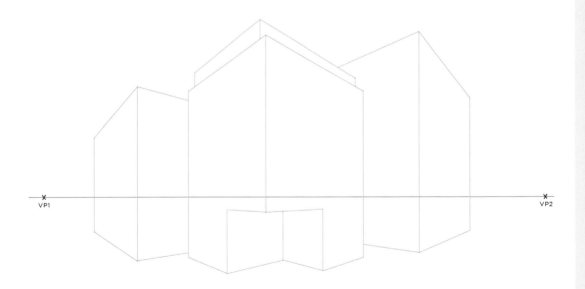

Step 10 Erase your lines to help you see things more clearly. (It can get confusing as you go.)

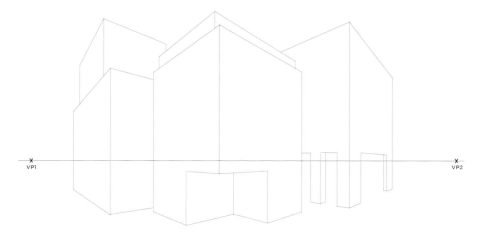

Step 11 Let's add a bit more to these blocks, but this time I'm not going to go step by step. I'm going to give you the end result; let's see if you can get there on your own. Use all of the techniques we've covered so far. I added another section over the building on the left, and I added columns to the building on the right. How did you do?

If you had problems, let's see if we can figure out where you went wrong.

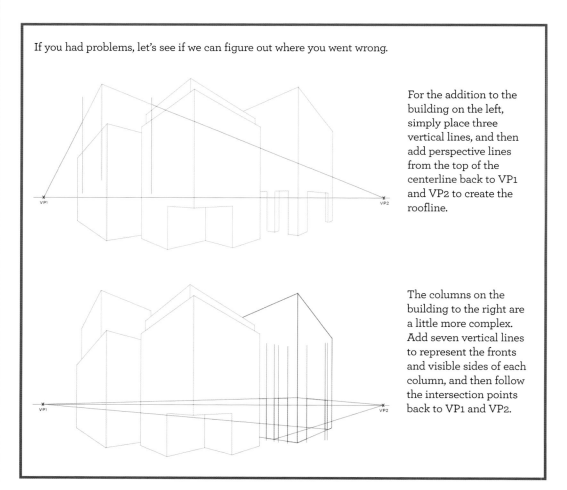

For the addition to the building on the left, simply place three vertical lines, and then add perspective lines from the top of the centerline back to VP1 and VP2 to create the roofline.

The columns on the building to the right are a little more complex. Add seven vertical lines to represent the fronts and visible sides of each column, and then follow the intersection points back to VP1 and VP2.

For measuring window spaces, I often use a simple index card with some divided hash marks; I sometimes find this easier than using a ruler, but any method of measuring will work. If you're working digitally, you can do the same thing without the index card; just make some measured hash marks on a separate layer in your file.

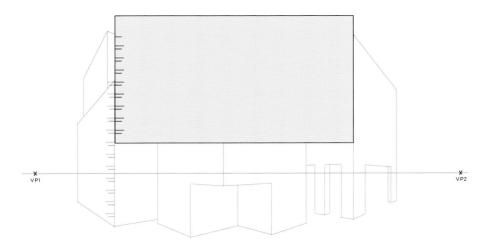

Step 12 Now let's turn these blocks into buildings by adding some windows.

Earlier, we saw how to place windows on a single-family house (pages 26-33). Those same principles apply here, only on a much smaller scale and with a lot more windows.

Place the index card with the hash marks (or the digital layer in your file) against the closest edge of the building on the left. Draw these hash marks down the side of the vertical edge. Move the card up and draw the rest of the hash marks. The divisions on the card are for standard-size windows with a space between each floor.

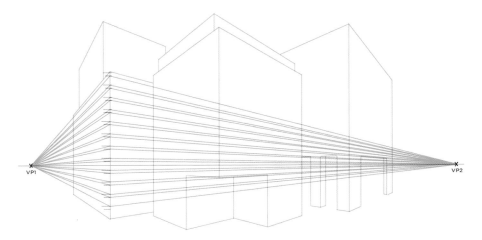

Step 13 Draw perspective lines from these hash marks back to VP1 and VP2; this marks the horizontal edges of the windows for this first building.

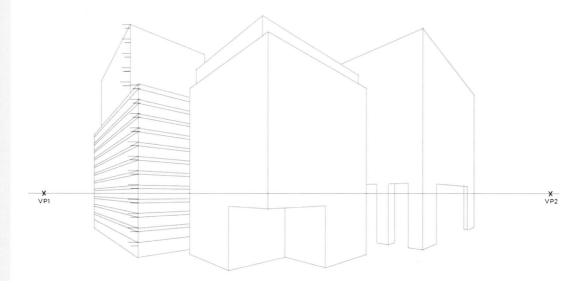

Step 14 Use the index card to continue the hashmarks on the upper part of the building.

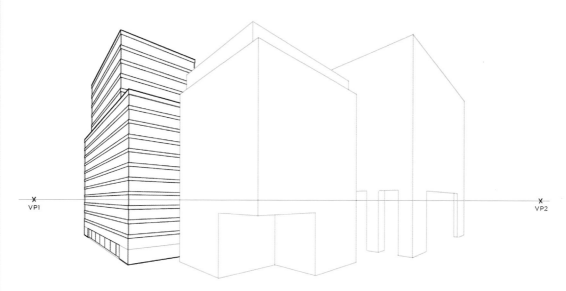

Step 15 Add perspective lines to add the horizontal window lines to the upper half of the building. Erase the extra lines and hash marks to see your lines more clearly, and then go over the lines in black. Note that I indented all of the vertical window lines to give the impression of glass sitting inside the building. I did the same thing on the ground floor to give the impression of doors.

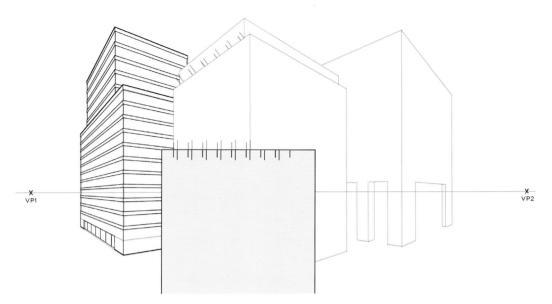

Step 16 Let's try something a little different with the middle building. It's always a good idea to vary the architecture in your buildings; otherwise, they'll look like they were made with a cookie cutter. Try building your window lines vertically. Use the index card to create hash marks horizontally, this time across the left face of the building. At the top, angle the card along the roofline to draw in the hash marks.

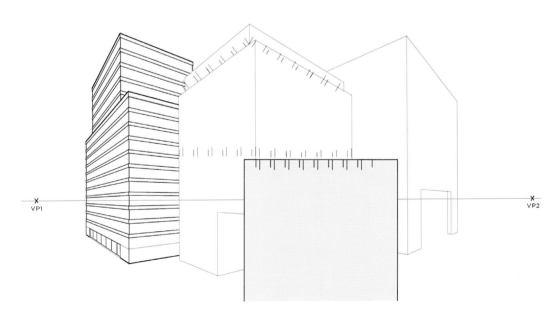

Step 17 But what if the hash marks don't fit exactly? As you can see above, the windows don't end evenly on the right side, because the right side of the building is slightly longer than the left side. So, we have to cheat a little bit. Eyeball those hash marks, and spread them out just a little bit; do the same thing along the roofline.

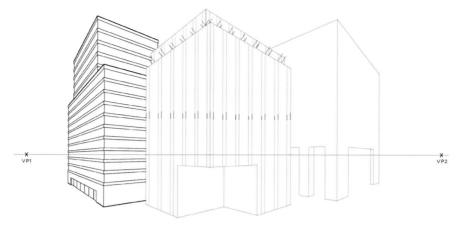

Step 18 Draw vertical lines through the hash marks to create windows on this middle building.

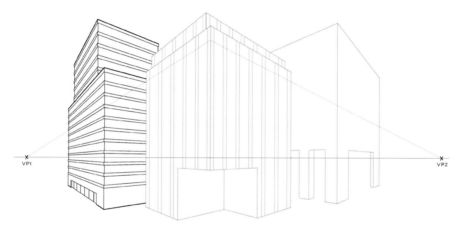

Step 19 Erase your hash marks. Add a divider on the building to give it a little more finish.

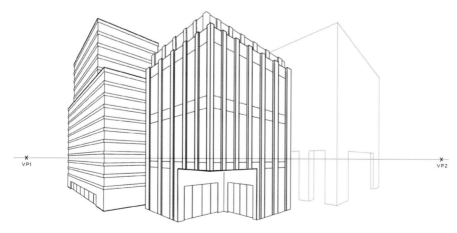

Step 20 The dividers are simply lines set along the perspective lines that follow back to VP1 and VP2. Do the same thing to create a door area underneath. Complete the building by going over the final lines in black and erasing all of the guidelines.

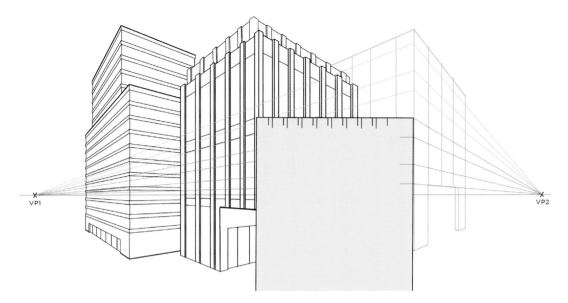

Step 21 Finally, it's on to the last building. Make some different hash marks on the other side of the index card to help make the buildings look different. Set up the spacing and add perspective lines from VP2 and then over to VP1. Use the same markings to add the vertical lines on the left side of the building. On the right side, eyeball what looks right, spacing out the lines fairly evenly.

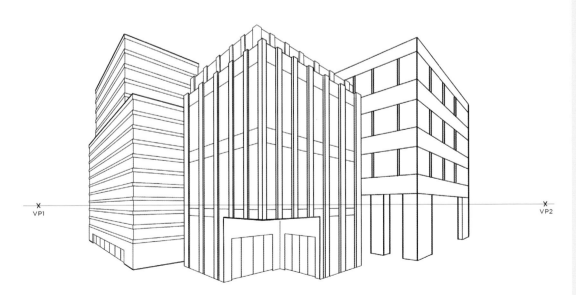

Step 22 Go over the lines with black to finish off the last building. There you have it; a small city block!

Advanced Two-point Perspective

In the previous chapter, we built a little city block in perspective; but now, let's fine-tune it using our two-point perspective skills.

Sidewalk

Step 1 Start with the sidewalk—it's a simple matter of drawing lines past the outer edge of the buildings from VP1 and VP2. Now, simply repeat the same line to create the curb edge—notice the line gets narrower as it goes back to each vanishing point.

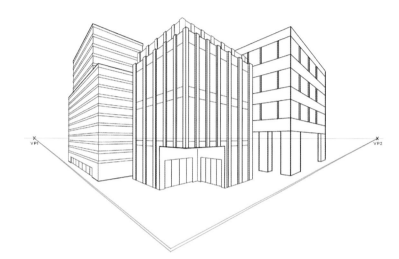

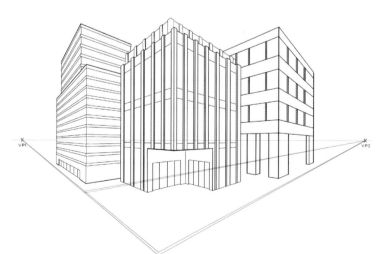

Step 2 But we're not going to leave it as simple as that—we're going to have the sidewalk hug the contours of the buildings like a real sidewalk would. Choose a point at the corner of Building 1 and draw that line back to VP2. Don't forget to add a second line to give the curb depth.

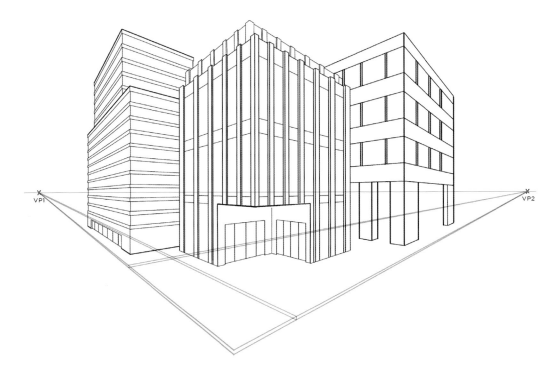

Step 3 The next set of lines go from VP1 along the corner where Building 1 and Building 2 connect. The curb should hug the outer contours of Building 2.

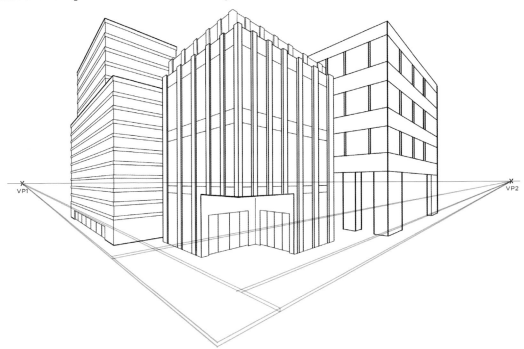

Step 4 Draw another set of lines along the outer edges of Building 2 on the right side from VP2. Follow the point from VP2 to the new curb line drawn in step 3.

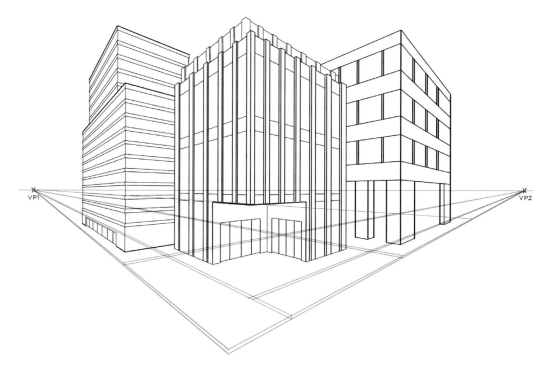

Step 5 The sidewalk should swing out again as you reach Building 3, so once again follow the perspective lines from VP1 along the outer edge of Building 3.

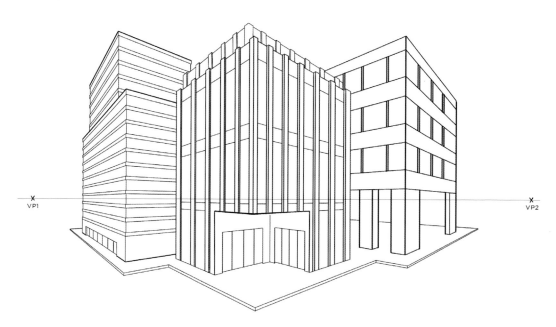

Step 6 We now have a sidewalk that wraps around our buildings. Outlining with black and erasing some of the perspective lines makes it a little easier to see. You might notice that I even closed off the block back behind Building 1. This line simply connects back to VP2.

Buildings

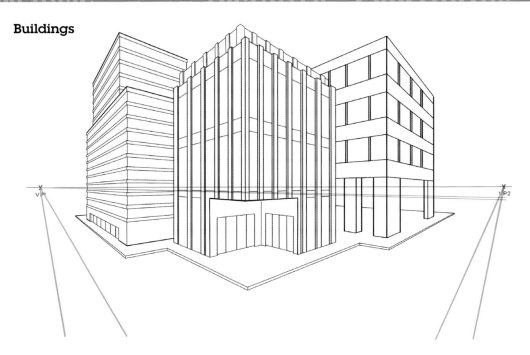

Step 1 Let's place some additional buildings around our city block. Draw in some additional sidewalks from VP1 and VP2, simply eyeballing the width of the street.

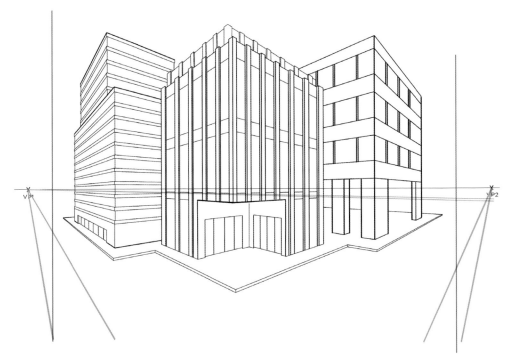

Step 2 Add two vertical lines at each end of the drawing, which will represent two other buildings set very close to the viewer. These new buildings will hide part of the new sidewalk on each side.

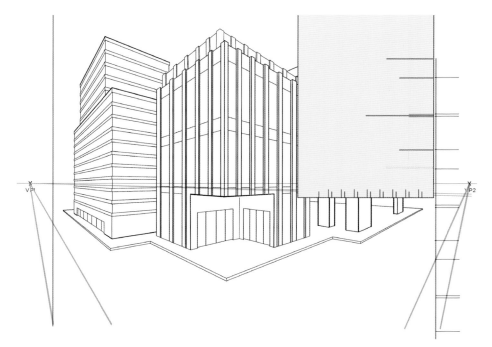

Step 3 Take out the index card you used previously, and make some new hashmarks for window spacing. Start at the top of the new building on the right and follow the hashmarks down. Note that the middle hashmark on the index card has two additional red lines—this center point will be the windowpane.

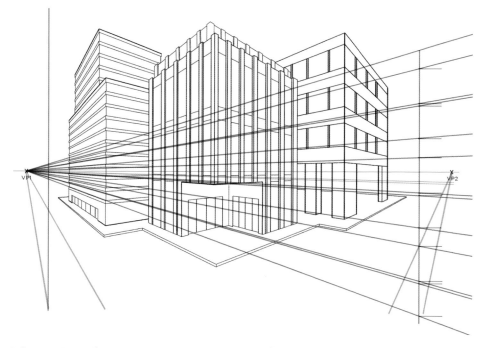

Step 4 When you're working in perspective, sometimes you have to take a minute to get your bearings. For this new building on the right-hand side, which surface faces us? The left side faces the viewer, which means the perspective lines should go back to VP1.

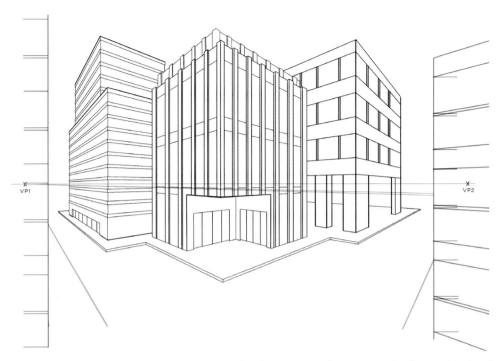

Step 5 Erasing the construction lines as you go will help you to see things more clearly. Go ahead and draw window lines using the index card on the building to the left.

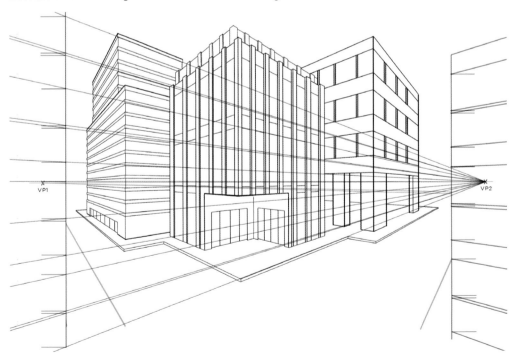

Step 6 As the right side of the building on the left faces the viewer, the window lines will all go back to VP2.

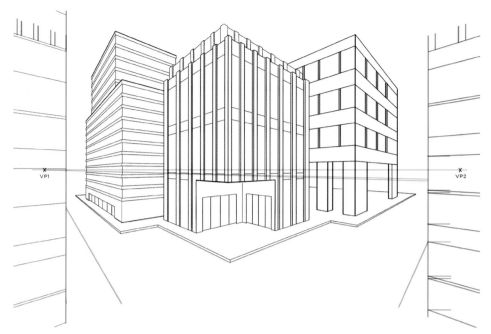

Step 7 Erase the extra lines so everything is more visible. Add measured hashmarks on both buildings to establish the vertical lines of the windows.

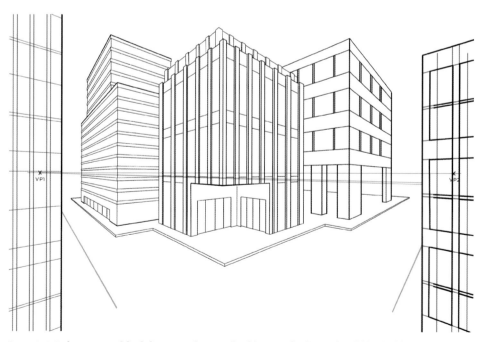

Step 8 Work up some black lines on the new buildings—the lines should be bolder than the lines of the buildings in the background because they are closer to us. Follow the perspective lines from the previous step, but add some depth as well. Draw in two vertical lines just to the right of each window edge on the building on the right. Close off the edge of the windowpanes to reflect this new window depth.

Because we've shown depth on the inside edge of the windowpanes, we also have to determine the depth of the top or bottom of the windows. This trips a lot of artists up, but it's relatively simple. If the plane exists above the horizon line, we should be able to see the upper edge of the window depth; if the window falls below the horizon line, we should see the lower ledge of the window.

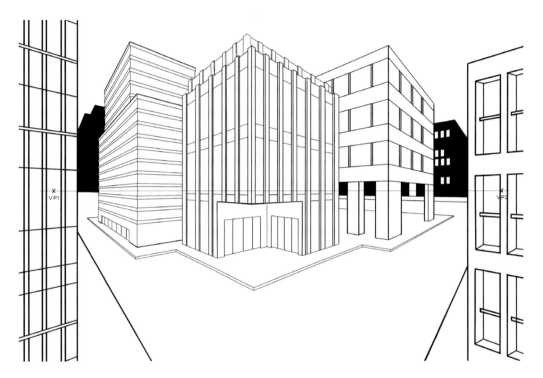

Step 9 Wrap up the basics by adding black lines and erasing the perspective lines and the rest of the blue construction lines. In the far background, place some buildings as simple shapes. They should follow perspective lines toward their respective vanishing points.

Light Posts

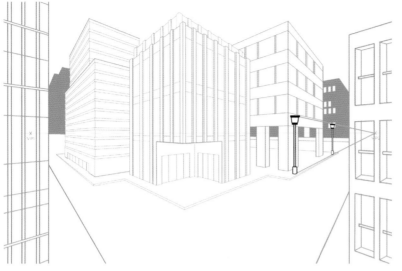

Step 1 Perspective can also be used to determine the size of objects in the distance; for instance, if you put a light post on the corner, simply follow the top and bottom back to the corresponding vanishing point (in this case VP2) to set the size of the next light post.

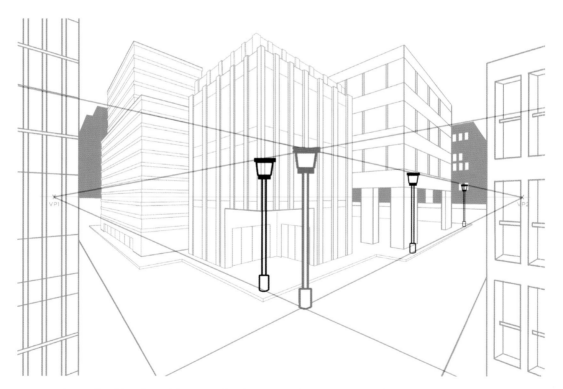

Step 2 That's all well and good for two poles that are on the same street—but what about the size of the light posts on the other side? And, in this case, when the sidewalk is not on the same plane? The first step is to extend the perspective lines from VP2 to determine the first setup. The red light post shows where the perspective lines intersect; then simply follow the perspective lines back to VP1. Place the new lamp post between the lines.

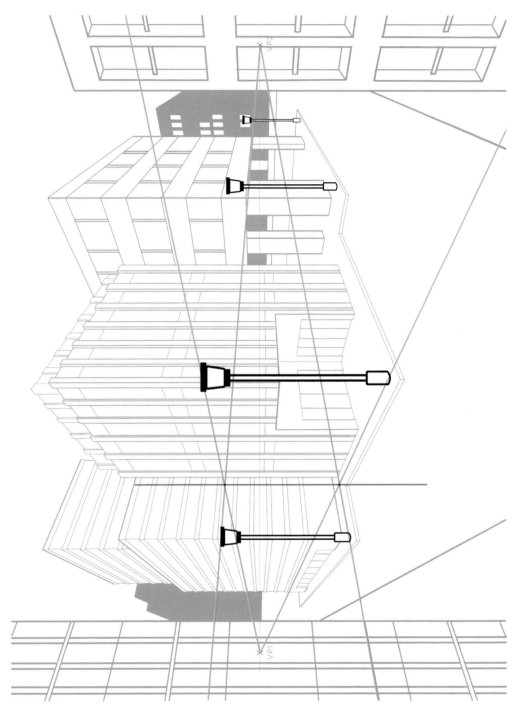

Step 3 Repeat the process for the lamp post on the next corner.

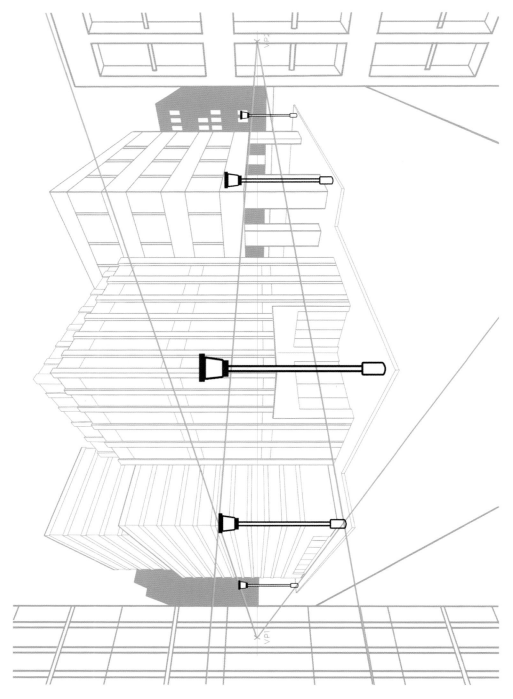

Step 4 And then again for the light post on the furthest corner. You can use this method for pedestrians, signage, or any objects you want to add to your illustration.

Vehicles & Signs

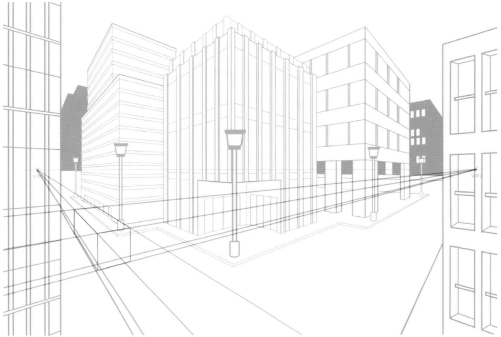

Step 1 It works for vehicles too! Using perspective lines, drop in the shape for a bus.

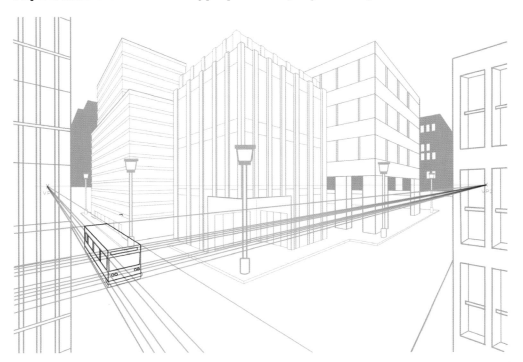

Step 2 Use VP1 and VP2 to work out the details on the bus. If you want to add a second bus behind the first, simply follow the same perspective lines.

A variable vanishing point (VPP) is used to represent an object that exists within our illustration but for some reason has moved into a position that does not meet with our traditional vanishing points. VPPs are set on the horizon line and placed closer together than the overall length of the object.

Draw lines from VPP1 and VPP2 to place the third bus. The horizontal lines are drawn slightly slanted; we could determine a VPP3 and VPP4 to be precise, but we'll just eyeball them with a slight angle.

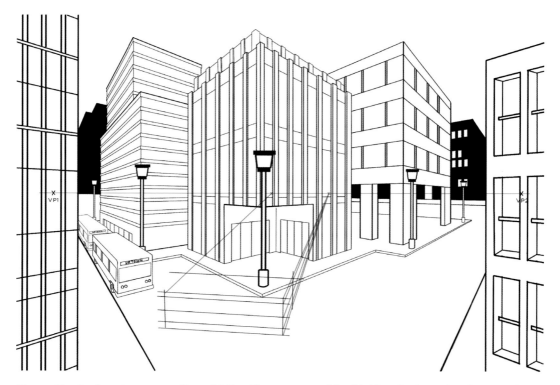

Step 3 Here's where it gets complicated. What if you want to add a third bus that's turning the corner? You can accomplish this using something called variable vanishing points.

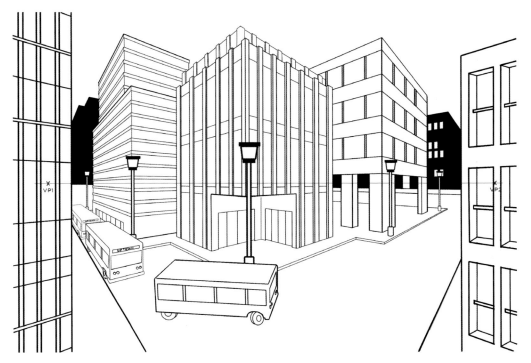

Step 4 Clean up the bus lines and erase the perspective lines.

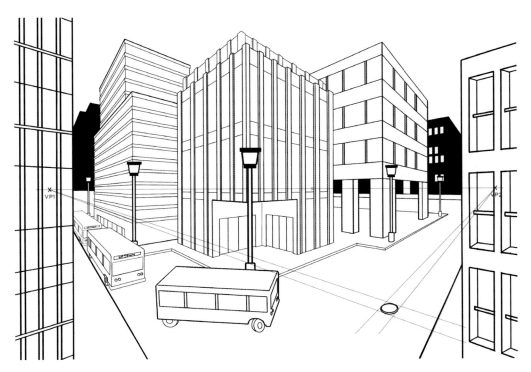

Step 5 Add a manhole cover by drawing a square which follows both VP1 and VP2 into perspective and then fitting the circle within its confines.

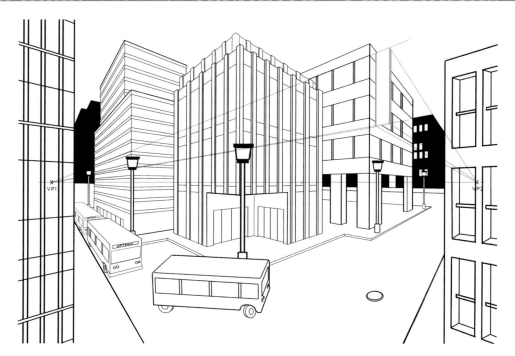

Step 6 The final step is to drop in a narrow sign that juts out from the edge of the building at right.

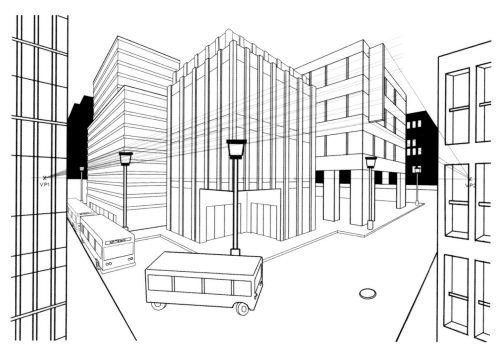

Step 7 Divide the sign panel into five parts using VP1 as the starting point. Go over the sign panel with black.

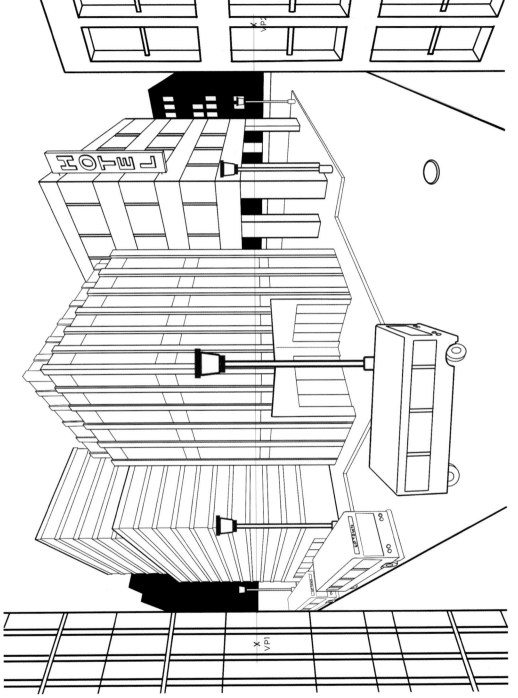

Step 8 Drop in the letters, following the perspective lines. Go over them in black and erase all of the construction lines.

73

Three-point Perspective

In many ways, three-point perspective is the easiest to master but hardest to understand. It's "easy" because every line now goes to one of three vanishing points (unless of course you have a variable, but don't worry about that for now) and "hard" because you have to visualize which vanishing point the line should go to.

It's important to get a firm handle on one- and two-point perspective before you jump to three. If you are the least bit unsure, go back and review those chapters.

Three-point perspective works best if you set the horizon line low or high. If you set it high, the image will appear as if you are soaring above a canyon or city, almost to the point of vertigo. If you set it low, the image will appear as if you're standing down within a chasm or beneath some tall buildings—or as we're going to do here, watching some blocks float over our heads.

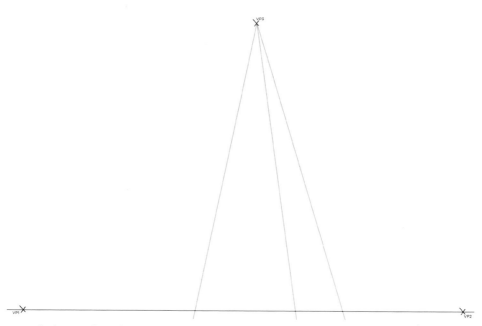

Step 1 Set the horizon line along the bottom of the paper and place VP1 and VP2 on each end. Add a third vanishing point (VP3) at the top of the page near the center of the horizon line. Draw three vertical lines down toward the horizon line.

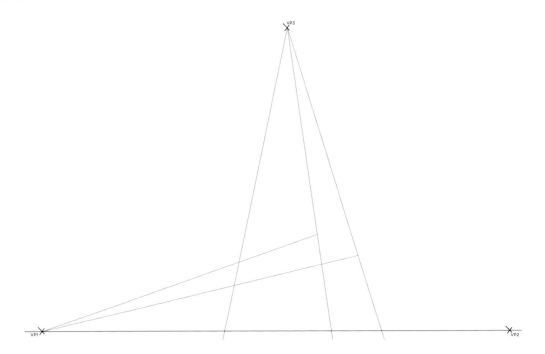

Step 2 Start by drawing the top and bottom lines for the first block. Draw two lines from VP1; one to the centermost VP3 line, and a second to the farthest VP3 line.

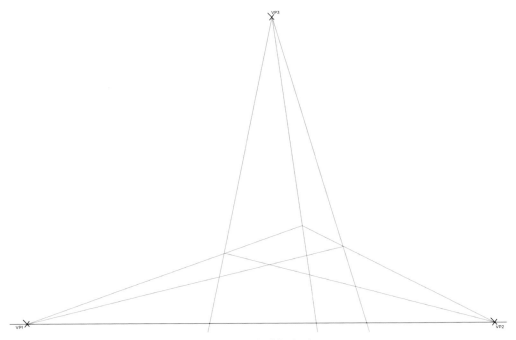

Step 3 Repeat with two lines from VP2; this creates the block's bottom.

Step 4 From VP1, draw another line up to the middle VP3 line to create the top edge of the block; then do the same thing from VP2 to connect the lines. Close off the block lines in black so that it's easier to "see" what you're drawing.

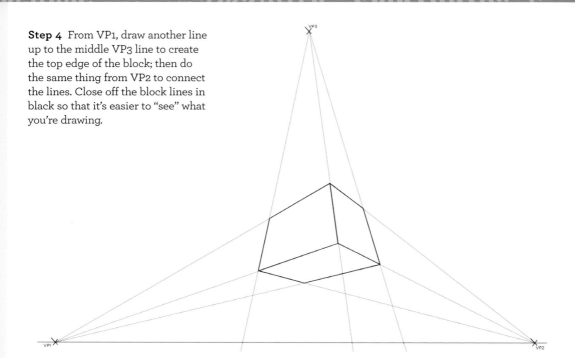

Step 5 Now draw a line from VP1 to the farthest VP3 line for the bottom edge of the middle block. Notice that this perspective line cuts through the first block; that's okay, they should have some overlap. Again from VP1, draw a second line to the middle VP3 line for the other bottom edge.

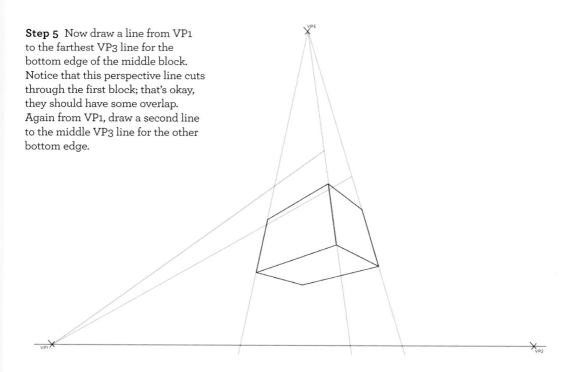

Step 6 Do the same thing from VP2, connecting with the lines from the previous step. Now you have the bottom edges of the middle block.

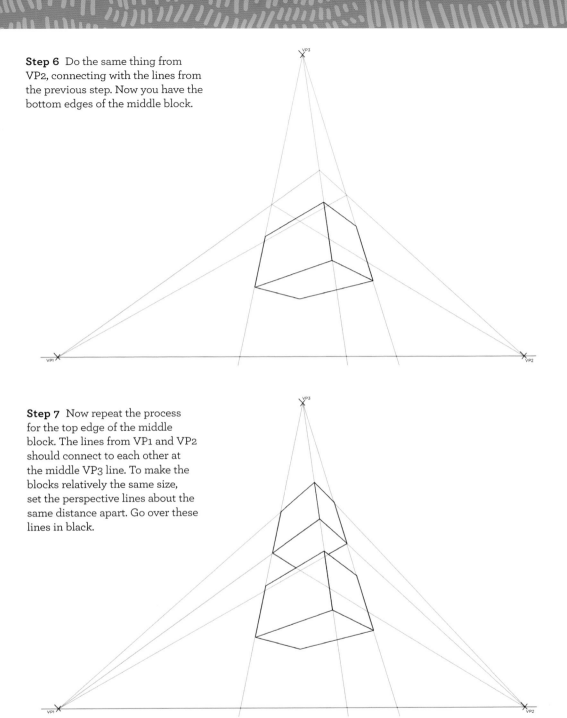

Step 7 Now repeat the process for the top edge of the middle block. The lines from VP1 and VP2 should connect to each other at the middle VP3 line. To make the blocks relatively the same size, set the perspective lines about the same distance apart. Go over these lines in black.

Three-point perspective allows us to see three sides of all the shapes. Each and every line must go to a vanishing point. Understanding which vanishing points just takes a bit of practice.

Step 8 The last block starts the same way as the other two—draw lines from VP1 and VP2 that connect at the middle VP3 line.

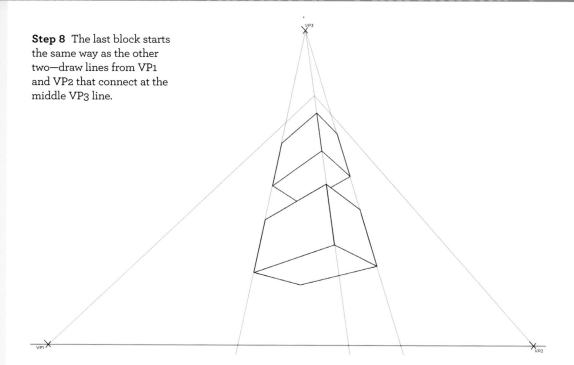

Step 9 Once again, the top of the block is drawn with lines from VP1 and VP2 that connect higher up on the middle VP3 line.

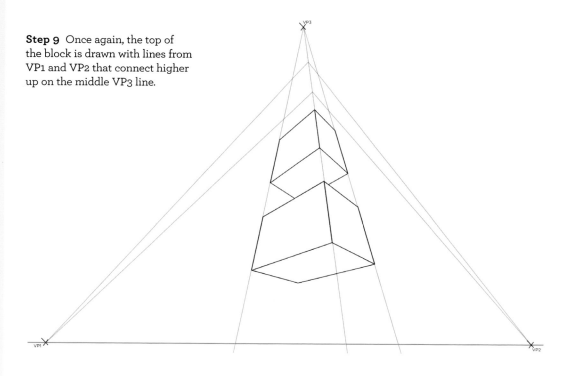

Step 10 Close off the block with lines from VP1 and VP2.

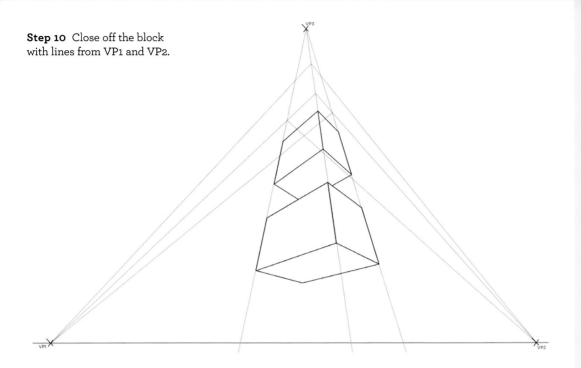

Step 11 Go over the lines in black and erase all of the perspective lines. You now have a three-tiered floating block set!

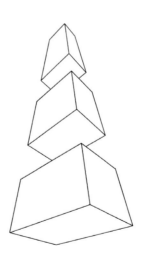

Three-point Perspective: Put It to Work

Three-point perspective in some ways is the simplest of all forms of perspective because all lines go to a vanishing point. The trouble happens when we choose the wrong vanishing point—so it's very important to focus on your perspective lines.

We're going to do a broader piece this time, using the "fan" method of perspective, which means we first draw all of the blue perspective lines to their vanishing points, and then we place the final lines over them.

Please note that we aren't going to get overly fancy or specific with details; the focus for this exercise is to gain a clear understanding of three-point perspective.

Step 1 Because perspective lines distort as they get closer to each vanishing point, we're going to do something a little different this time. We're going to set the VPs off of our illustration area. The box represents our illustration; if you're working traditionally, you can tape a piece of paper to a larger board.

Place a horizon line and two vanishing points at each end. We also need to add a third vanishing point at a location somewhere off of the horizon line, in this case setting it far below the horizon line. All of these VPs are set off of our paper. If you're working traditionally, place pieces of masking tape where you want your various VPs, and then draw the Xs on the tape.

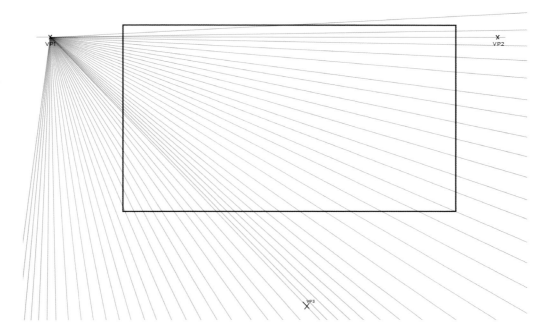

Step 2 Draw in perspective lines from VP1 branching out across the illustration, letting them run off the page. The more lines you draw, the more concise your illustration will be. However, the choice is up to you: Too many and you'll just have a blur of blue lines; too few and you'll have a hard time finding guidelines.

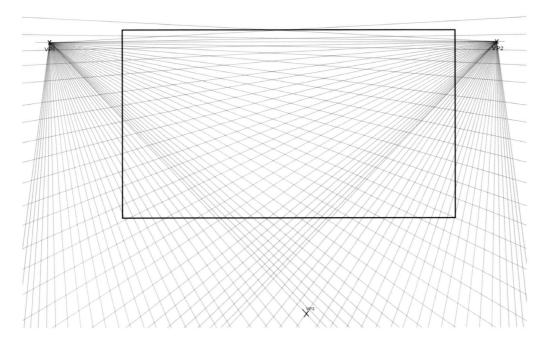

Step 3 Do the same from VP2. These perspective lines will cross each other.

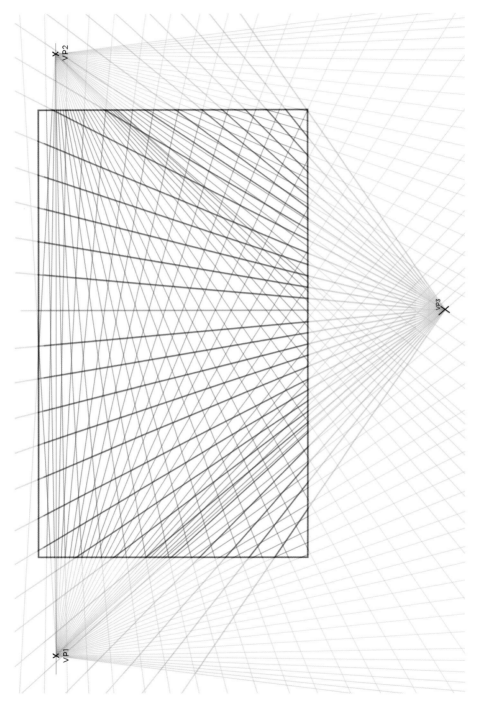

Step 4 The perspective lines from VP3 fan up and cross all of the previous lines. If you look toward the edges of all the intersecting lines, you will see a slight distortion—like a fish-eye effect—which is why we want to set the vanishing points off of the illustration. Lighten all of the perspective lines off of the illustration, so you can better focus on the image area, which is less distorted.

Buildings

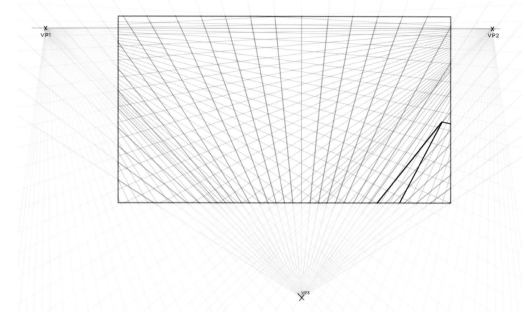

Step 1 It's easiest to start with the roofs and foreground of the buildings. The first rooftop will be at the bottom right. All of the roof lines will go to either VP1 or VP2; the wall lines will all go to VP3. Speaking of walls, the wall of this building will go to VP3. This finishes up the first building.

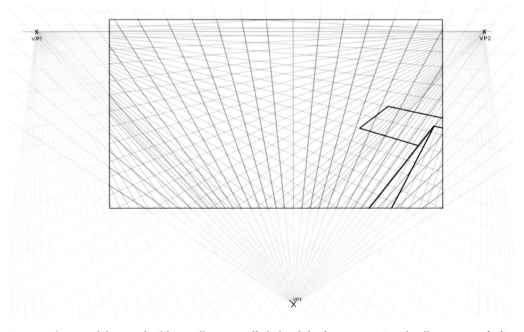

Step 2 The top of the next building will sit partially behind the first one, giving the illustration a feeling of depth. These lines go to VP1 and VP2.

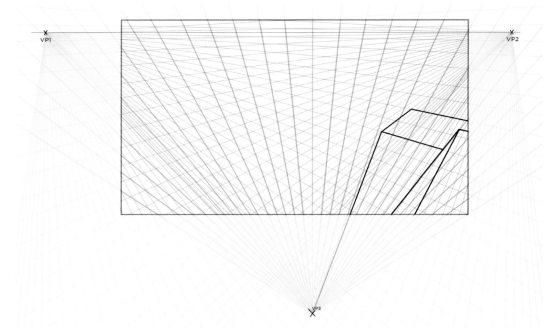

Step 3 The front wall of this building goes to VP3. You'll notice that it doesn't follow any of the existing blue perspective lines we've drawn—that's normal; those are just guidelines to help us lay out the space.

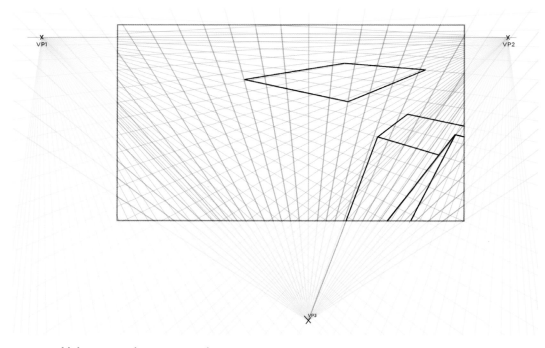

Step 4 Add the next roof using VP1 and VP2.

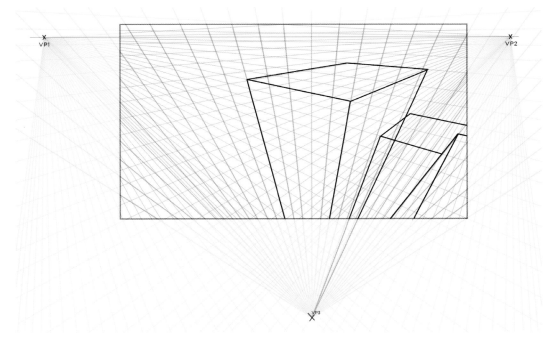

Step 5 The wall lines for this one go to VP3—the furthest right wall goes through the previous building; erase the line where it intersects.

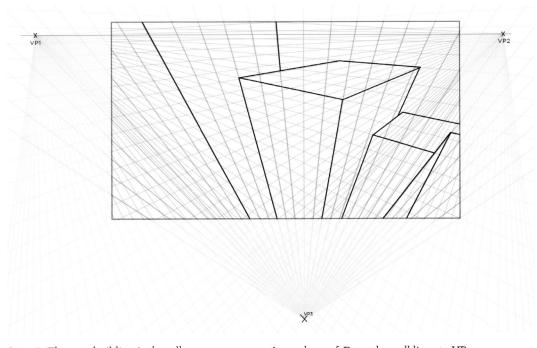

Step 6 The next building is the tallest one, so we won't see the roof. Draw the wall lines to VP3.

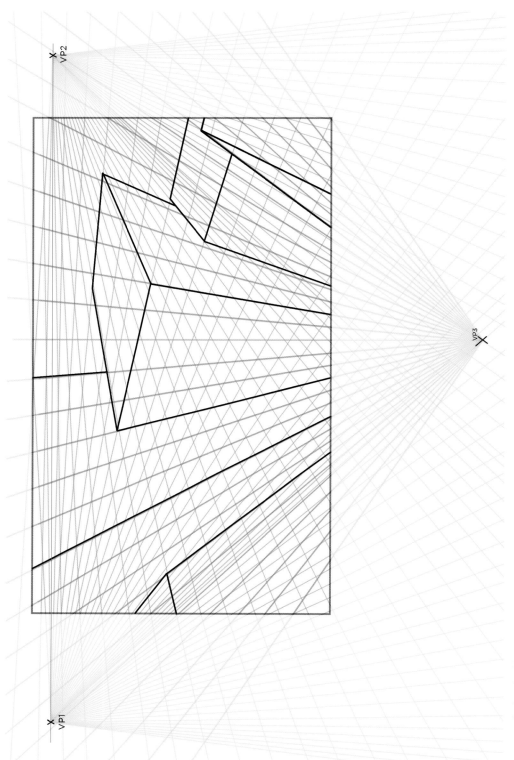

Step 7 The last building will be on the far left; the roof lines go to VP1 and VP2, while the wall line goes to VP3.

Windows, Building 1

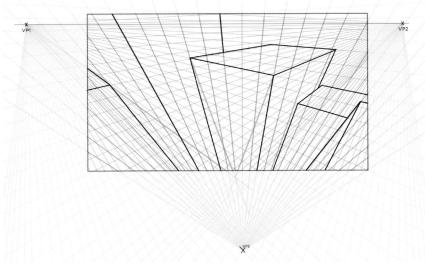

Step 1 We now have the "skeletons" of the buildings. Now let's figure out some of the window lines, which is complicated, but fun! Determine the center point of the building by drawing lines from each corner to the opposite corner. Draw a line from VP1 through this center point to start the window height divisions.

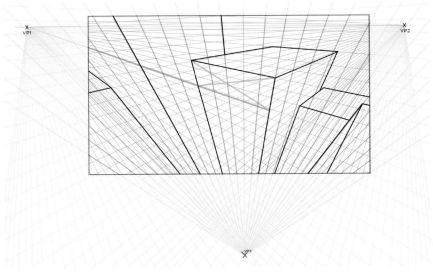

Step 2 Start by drawing a line about ⅕ of the way down from the top of the building— this random placement is going to establish the windows. Now divide this space by drawing an X from each of the four corners.

We call this "divide and conquer"—we have to get the spacing of the windows correct as they travel down toward the vanishing point. Like a railroad track converging toward the horizon, the windows should converge toward VP3, so we can't simply use hash marks like we did with one- and two-point perspective.

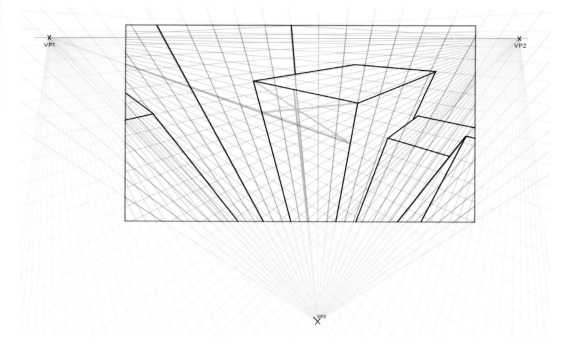

Step 3 Draw a new centerline up from VP3, giving us a midpoint for the building.

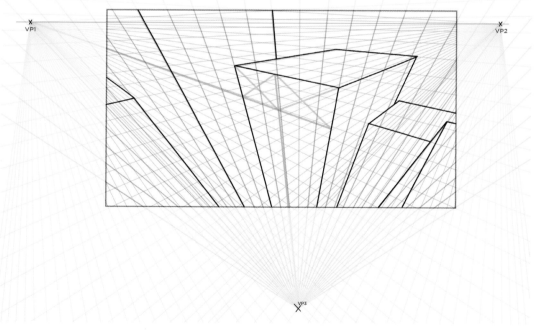

Step 4 Erase the original X and draw in two new Xs from the four corners of each half.

Step 5 From VP3, draw two more centerlines up through these new Xs.

89

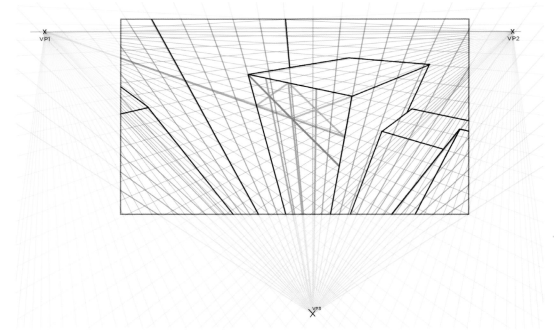

Step 6 Next we have to determine the distance to the next set of windows. This is a little bit tricky. From the top-left corner of the newly divided area, go through the first X center point, which follows down through the bottom-right corner of the first block, and follow it all the way down until it hits the right edge of the building. Place the next set of windows here.

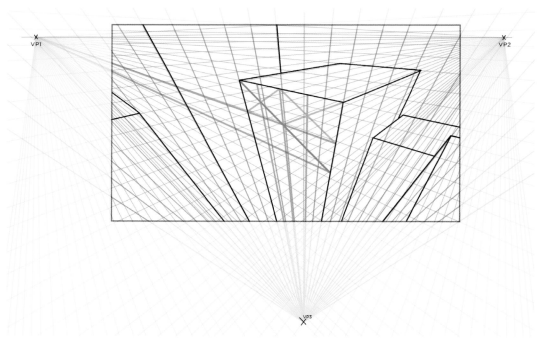

Step 7 Draw a new horizontal midpoint line from this connection point back to VP1.

Step 8 Repeat for the next window point.

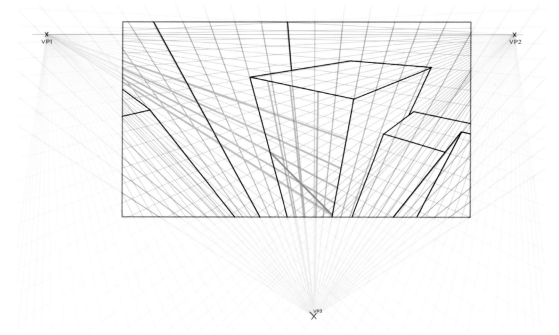

Step 9 And again.

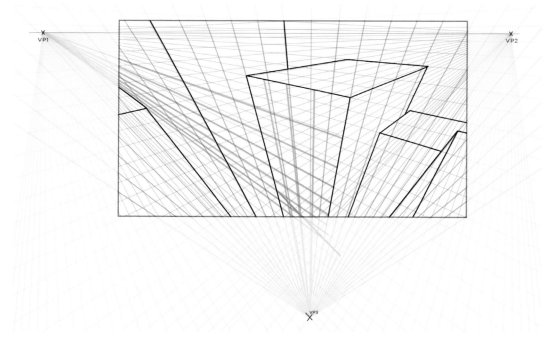

Step 10 And again. We have now placed the vertical lines for the windows.

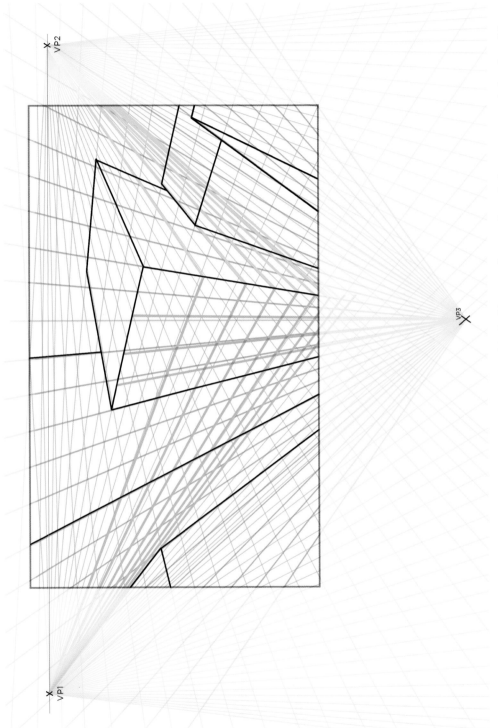

Step 11 This also gives us the vertical lines for the windows on the other side of the building, simply start where the lines connect with the edge of the building and follow them back to VP2.

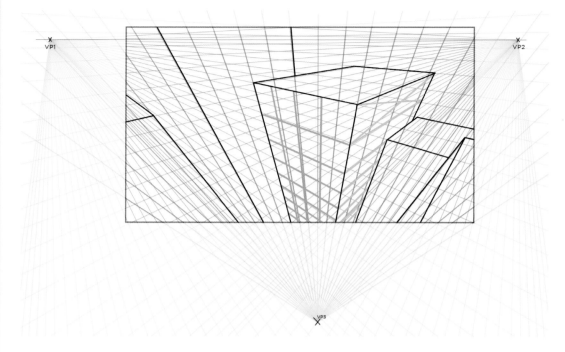

Step 12 Now draw an X in one of these newly formed segments to get the center point.

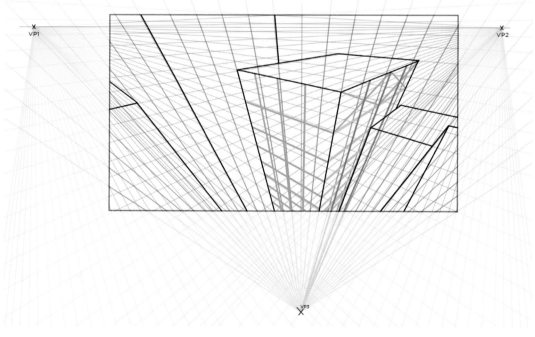

Step 13 Draw a line up from VP3 through this point. Divide these two blocks using Xs to get new center points. Draw vertical lines up from VP3 to break this side of the building into four segments.

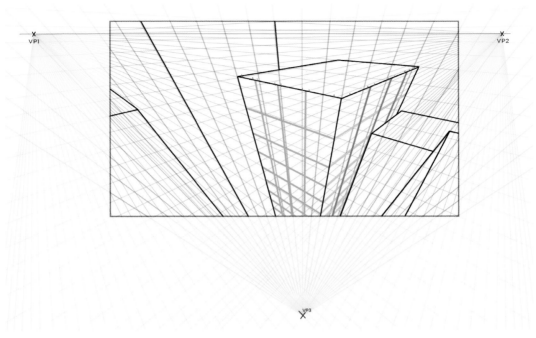

Step 14 An easy way to add the windows is to put two small lines on either side of the centerlines (done here in red) to give us a general placement for the windows. "Eyeball" the placement, making the space slightly wider as it gets closer to the front edge of the building.

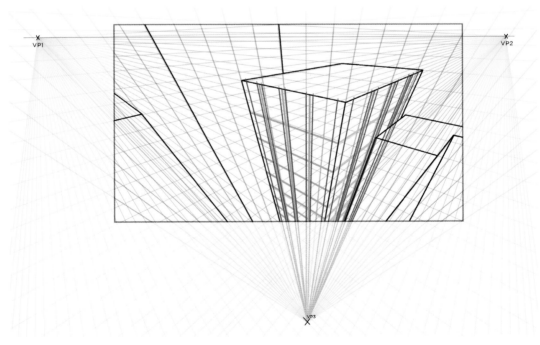

Step 15 Draw vertical lines up to these window marks from VP3, creating the window spaces.

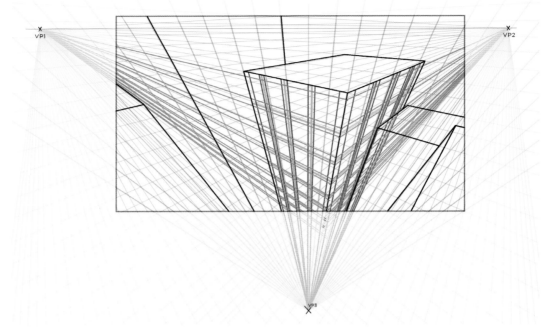

Step 16 Do the same thing for the horizontal window marks, placing them down the right edge in the foreground.

Step 17 Now draw in the lines from VP1 and VP2.

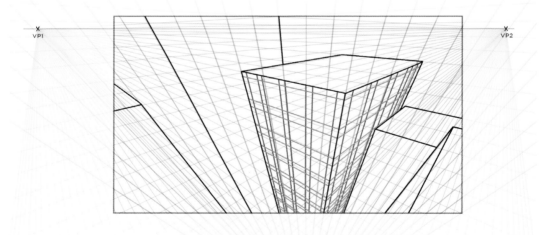

Step 18 Erase the window marks and the excess lines for clarity.

Step 19 Close off the lines in black to create basic window shapes.

Windows, Building 2

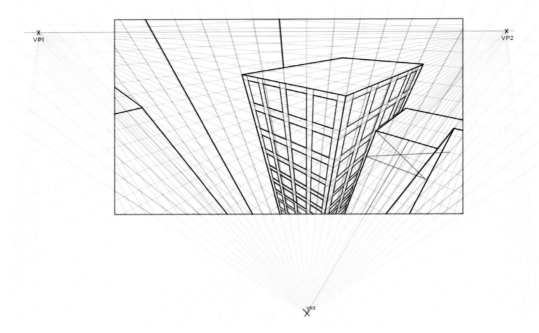

Step 1 Let's do the same thing for the building next door, using the X-division method to arrive at our spacing.

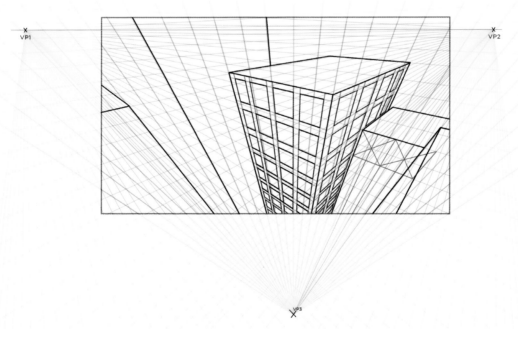

Step 2 Divide this block into two. Note that the lines extend behind the edge of the building on the right; this is the edge of the building hidden behind the other.

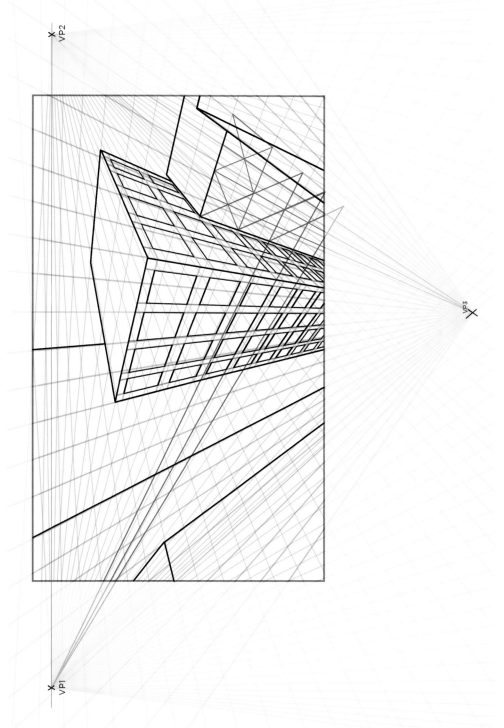

Step 3 Using the two new blocks, draw a line from the top-left point of the block down through the center point until you reach the outer edge of the building. Continue down to place all of the windows.

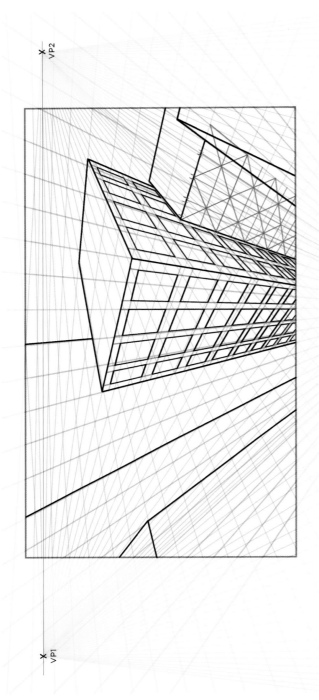

Step 4 These new blocks must also be divided into halves using the X method to give us the center point of each new area. Draw an X using the corners of each new block, and then draw a center point through each X back to VP3.

Step 5 Now drop in the window hash marks again, spacing them out just slightly around the horizontal and vertical lines.

Step 6 Draw lines to the window marks using the respective vanishing points.

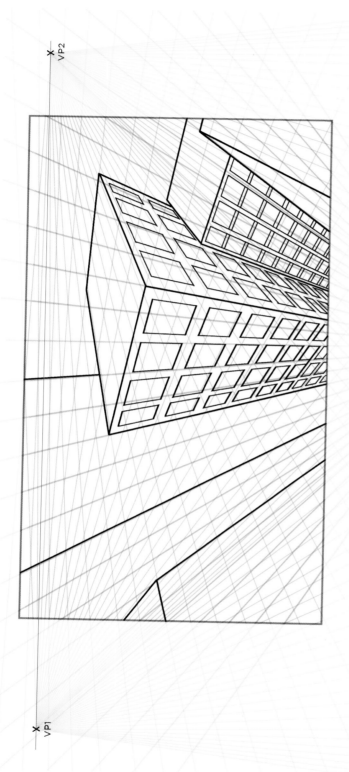

Step 7 Follow these lines to draw in the windows.

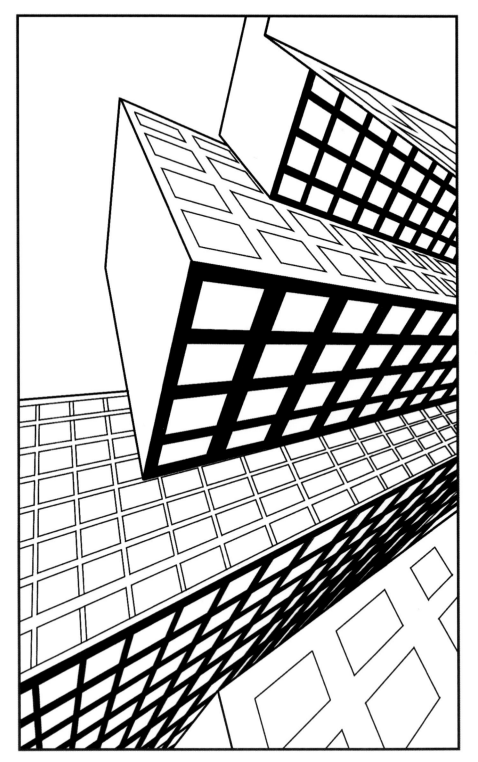

Step 8 Now repeat the same methods to place windows on the other buildings. If you get stuck, refer back to the previous steps. You can add black to the same side of all the buildings for a dramatic effect. How did yours come out?

Casting Shadows Using Perspective

Start with the final two-point perspective building illustration on page 65. We have already established the horizon line and the existing vanishing points. Now we need to choose our Light Source Vanishing Point (LSVP); this point can be randomly placed with two exceptions:

- If you're trying to illustrate an early or late part of the day, which would give long cast shadows. In this case, you'd set the LSVP extremely far to the left or right.

- If it is high noon, you would have no shadows other than directly beneath each object. In this case, you'd only see shadow under the elevated building.

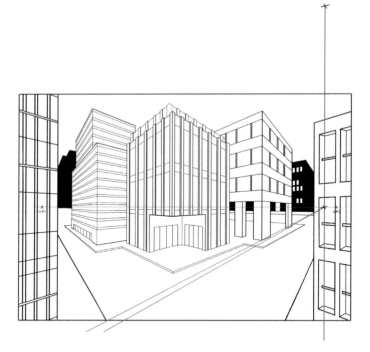

Step 1 For this example, place the LSVP high and to the right. This will give ample shadows for the illustration without having to extend the horizon line.

Now establish the base point and the high point of the shadow lines. To start, place a vertical LSVP line. This vertical line intersects with the existing horizon line and gives the base point for the shadows.

Step 2 Put another VP where this vertical line intersects with the horizon line. From this new intersection point, draw perspective lines for the first set of shadow lines, which are cast by the building's right-most columns.

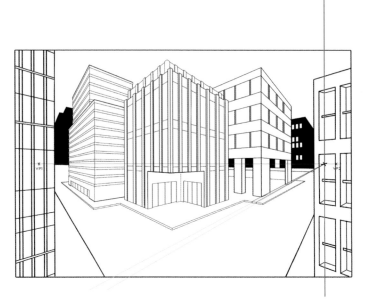

Step 3 But there's a curb to contend with ... you didn't think this would be easy, did you? Don't worry; it's not that bad. Simply cut off the line at the edge of the curb, draw two vertical lines down the curb edge, and then reconfigure the remainder of the perspective line using the LSVP vertical intersection point (shown here in green).

Step 4 Now it's on to the next column, the one closest to the viewer. Arrive at these shadow lines the same way, starting at the LSVP intersection point. The right edge of the column intersects with the shadow line you've already drawn from the first column, so skip this line and jump to the left corner, which also presents a minor obstacle, as you intersect with that curb again. Use the same method here as in the previous step.

Step 5 Take care of the last column, noting that the perspective line is going to end as it hits the building in front of it.

Step 6 Now place the top line. Go from the LSVP down through the closest outside corner of the building on the right, and draw that line down to the closest perspective line from the LSVP intersection point. This line will determine the height of our shadows.

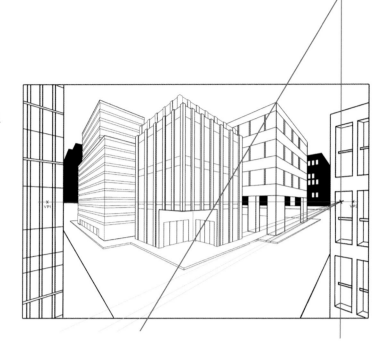

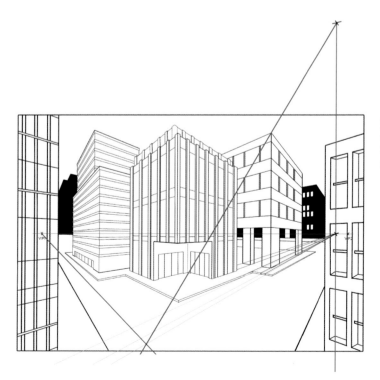

Step 7 From VP1, draw a line that connects with the intersection point of the line from the previous step.

Step 8 Next, we'll draw the LSVP intersection line for the next building. This shadow is also going to come into contact with a curb; so again, do the usual cut, vertical line on the curb, and new drop line. However, note that there is a second curb, the one closest to the viewer on the left side of the street. Make sure the shadow line extends up on that same curb level; draw it right across, simultaneously with the dropped line for the street.

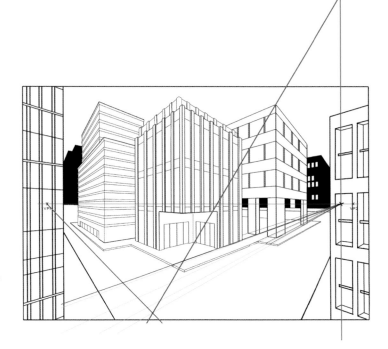

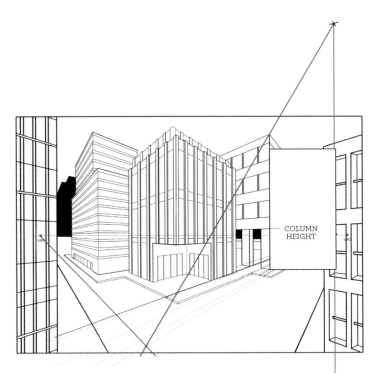

COLUMN HEIGHT

Step 9 Note the height of the columns using your trusty index card.

Step 10 It's not an exact science (more like eyeballing it), but use that height measurement for the shadow. Draw a little line there and a perspective line from VP1 to this point.

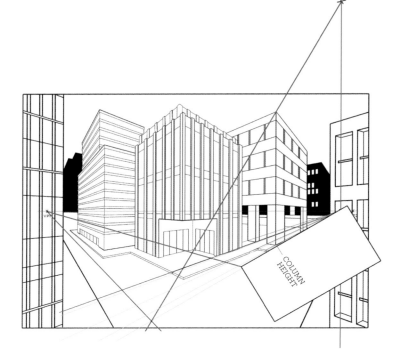

COLUMN HEIGHT

Step 11 Again, there is a curb to contend with, so cut at the curb edge, vertical line, and perspective line from this new point.

Step 12 Draw in the back shadow line (green) of the building farthest away from the viewer, from the LSVP intersecting point to the back corner of the building on the left. There is a curb here too, but it's so far away that the distance will be negligible.

Step 13 Add a sliver of light between the two buildings on the left; there is a curb there, so do the cut, drop, and place technique, as you did with all of the other curbs.

Step 14 Go over all of the shadow guidelines in black. For that negligible back shadow curb, simply drop the line slightly as it leaves the sidewalk.

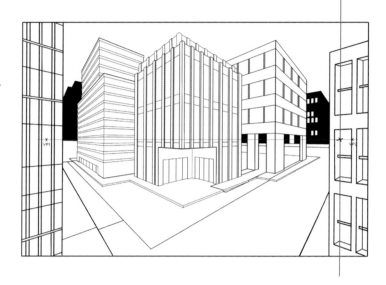

Step 15 Now the fun part; fill in all of the black outlines to create shadows. When complete, the shadows give the impression of early morning or late afternoon, but you can still see all sides of the buildings.

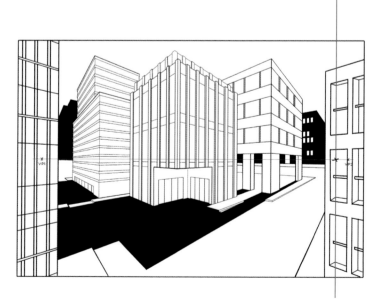

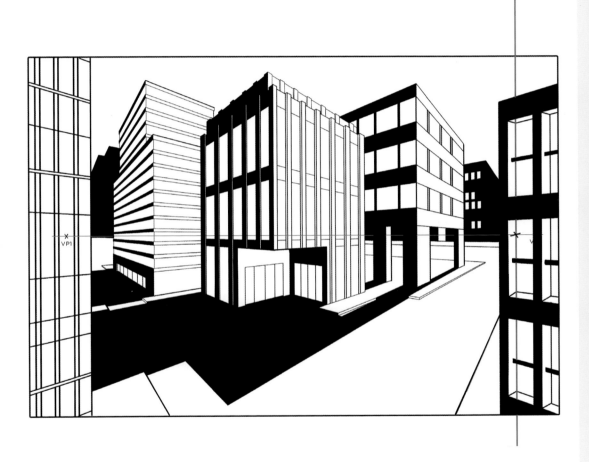

Step 16 Carry the shadow through to the buildings themselves. Because the light source is set to the right, the shadows fall on the left, which means the left sides of the buildings would also be in shadow. Adding shadow often adds an element of reality to any illustration.

Final Thoughts

Perspective is a complex combination of art, science, and math, but it doesn't have to be incomprehensible. Take the time to go back through the book and work up the exercises as you need additional practice. You'll soon find that you not only understand perspective and how it works, but you'll start seeing the potential of 3-D in your 2-D drawings.

About the Artist

Andy Fish studied art at The School of Visual Arts in New York City, as well as Rhode Island School of Design. He is a former professor of illustration at Massachusetts College of Art and Design and a record-setting ten-term Artist Mentor at Art All-State, a program teaming New England's most promising artists with established professionals. Andy continues to teach private online classes, as well as serve as a professor of Graphic Novel Studies at Emerson College in Boston, Massachusetts. He has a diverse client list including most of the major comic book companies.

Also available from Walter Foster Publishing

978-1-63322-856-6

978-0-92926-113-3

978-1-63322-699-9

Quarto Knows

Inspiring | Educating | Creating | Entertaining

Visit www.QuartoKnows.com